A concise history of
IRISH ART

A concise history of
IRISH ART

Revised edition

Bruce Arnold

179 illustrations 20 in colour

Thames and Hudson

© *Bruce Arnold 1969, 1977*
First published in 1969
Revised edition 1977

Printed in Great Britain by Jarrold and Sons Ltd Norwich

Contents

Introduction

There is a widely held fallacy that Ireland's contribution to the art of the world has been almost exclusively in the realm of the written word. This book is an attempt to prove otherwise. For example, it is difficult to say which of the two Yeats brothers was the greater artist, Jack the painter, or William the poet. The question is answerable in more than just personal terms. The fine early drawings repeatedly strike echoes in the lyrics of the rhymer. And a great poem like 'Sailing to Byzantium' can almost be taken as a direct comment on *Ill. 1* the shadowy world of a great painting like *About to Write a Letter*. In the painting the vision of the artist has become universal and immensely powerful. And in the poem the same thing has happened. The two can strike chords in each other, and it is even possible to imagine the pensive, hesitant figure in oil paint speaking the lines –

> *Consume my heart away; sick with desire*
> *And fastened to a dying animal*
> *It knows not what it is; and gather me*
> *Into the artifice of eternity.*

Yeats the poet was a figure to be reckoned with at the turn of the century. He was a legend in his own lifetime, and while his brother was still only understood and loved by a small group of admirers, the poet was regarded as one of the great writers of the twentieth century. There has been some change in this state of affairs during the last ten or fifteen years, yet still Jack B. Yeats remains an under-rated and unexplored artist, and, what is more important from the point of view of this book, he is to a great extent regarded as a unique and uncharacteristic phenomenon in a country which has little or no tradition of visual art, and no artists in the past of comparable stature.

The visual arts in Ireland during the early Christian period are well-known and justly celebrated. What is not accepted to anything like the same extent is the fact that various artistic traditions were established during the intervening centuries since the golden ages in *Ills. 21–3,* which the Book of Kells, the Ardagh Chalice and the Cross of Cong *14, 31–2* were produced, and that these traditions grew, expanded and

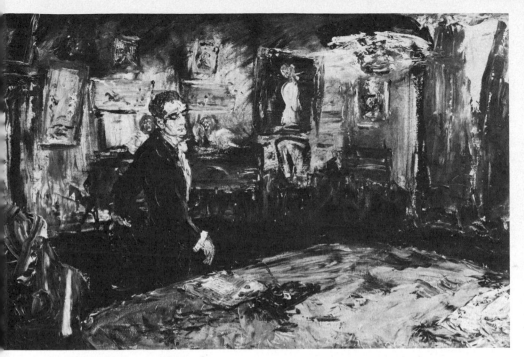

1 JACK B. YEATS *About to Write a Letter*

enriched themselves, and ultimately produced artists of considerable stature. Various forces, however, have operated against the emergence of any clear idea of Irish art, with a character and style of its own. History has given to most of the artists of the seventeenth, eighteenth and nineteenth centuries the unfortunate labels of 'Anglo-Irish', 'Ascendancy' or 'Plantation'. Many of the better Irish artists have been forced by circumstance, or persuaded by ambition, to seek a better fortune in London, and their reclamation here may seem impertinent. Still others are known by a mere handful of paintings, the majority of their work having been re-attributed, and their pictures now masquerading in public collections under more illustrious names.

In spite of the temptations to be greedy about individual artists in pinning Irish nationality upon them, my first concern has been with the idea of an Irish art, developing, changing and enriching itself in spite of history rather than because of it. Artists tend to be the least patriotic of men, and the question of nationalism is not one with which they are greatly concerned. Yet in many areas – landscape,

topography, portraiture, historical painting, silver, glass, even architecture – a distinctive national style and character, a difference of light, a sense of history evolving and of people being involved in it, are all contributory factors to the overall idea which has been the mainspring of this book.

In a number of areas it covers ground which has not been touched on before. While the art of early Christian Ireland has been extensively studied by Mlle Françoise Henry and other scholars, there is no general history covering either the period since then or any considerable section of it. Invaluable work has been done on individual artists, notably by W. G. Strickland in his *Dictionary of Irish Artists* and by Thomas Bodkin, but their works are hard to come by, and, in the case of the former, tend to be rather academic in appeal. Much of the other published material is listed in the Bibliography.

I would like to thank the many people who gave me help and advice in the writing of this book.

Revised Edition

It is eight years since the first edition of this book appeared. In that time much new material has come to light, particularly covering the eighteenth century, but also on other aspects of Irish art. For the most part the aim in revising the book has been to put right fact and emphasis where these are affected by new discoveries, and though the temptation has been there to make wider changes, economic considerations have confined these. I am particularly grateful to Miss Ann Crookshank, of the Fine Art Department in Dublin University, and to Mr Ted Hickey, of the Art Department in the Ulster Museum, for their practical help and encouragement.

Bruce Arnold

The Celtic era

Irish art begins as abstract art: the ritual decoration by early Bronze Age man of the tombs of his ancestors. His art is a complex pattern of loops and spirals, diamonds, zig-zags, triangles and squares, pecked out in the granite kerb-stones, and cut into the pillars and stone slabs of passage graves and burial chambers. The artist-sculptor follows the shape and contour of the stone on which he works. His thinking is three-dimensional, and his concern is with harmony, rhythm and the balanced pattern of simple abstract forms, rather than with any attempt at representational art reflecting his immediate animal or vegetable environment. In this sense it seems spiritual in nature, belonging to the realms of pagan magic, possibly part of a heathen religious cult which in all other respects is lost to us for ever.

It begins a tradition in art that can be traced from the early Bronze Age to the first full flowering of Irish art in the immensely rich early Christian Celtic period, from the coming of Saint Patrick to the war and desolation of the Viking invasion of the ninth century.

In its early, pre-Christian period it should not be seen as a national art. Ireland was part of the Celtic world, and her art closely tied up with Celtic culture, a European phenomenon, stretching from Spain to the Scandinavian countries, and from Hungary to the Atlantic coasts of Kerry and Donegal. The Celtic world knew no centre, nor was it conscious of its own unity. Its peoples were far-flung and communication between them was immensely difficult and slow. Yet in language, myth, ritual, belief, literature and art they were one. And when Diodorus, in the first century BC, was describing the Celts of Gaul in his history of the world, he was really speaking of one people whose territories had covered most of Europe and whose racial characteristics were identical far beyond the confines of the area he was writing about. What he had to say about the Celtic people and their distinctive character tells us much about their art:

> In conversation they use few words and speak in riddles, for the most part hinting at things and leaving a great deal to be understood. They frequently exaggerate with the aim of extolling

themselves and diminishing the status of others. They are boasters and threateners and given to bombastic self-dramatization, and yet they are quick of mind and with good natural ability for learning.

It is not surprising that such a people, with so distinctive an attitude to the unconquered world they lived in, so different from the Romans or the Vikings, their latter-day vanquishers, should have produced an art of such originality, refinement and style.

The earliest manifestations are of uncertain date. The great heathen sanctuary at New Grange, in County Meath, may be as early as 3000 BC. The passage grave at Knowth, which resembles it in many respects, has been dated approximately at 2500 BC. And the graves at Carrow Keel belong to the same period. Yet Iron Age remains have been found at the last of these, and it is reasonable to suspect that these tombs and sanctuaries, dating originally from the Neolithic period, passed down through the centuries into the Bronze Age and the Iron Age, without losing their sacred significance. What is fairly certain is that the decorations we have from these tombs belong as firmly to

Ill. 16
Ills. 26, 27
Ill. 2

Celtic art as do the decorated pages in the Lindisfarne Gospels, or the carved panels on the Cross of Moone.

The kerb-stone at New Grange is covered in a close pattern of spirals, the most common of all the motifs decorating these tombs, and one basic to all Celtic art. The lines flow into one another, the shapes adapt themselves to the contour of the stone; at one point the spirals give way to a diamond pattern, breaking the subtle harmony and introducing a note of paradox at the end of this silent motto.

2 The decorated kerb-stone at the entrance to the burial chamber at New Grange, Co. Meath, *c.* 3000 BC

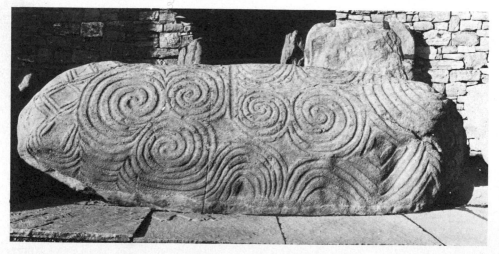

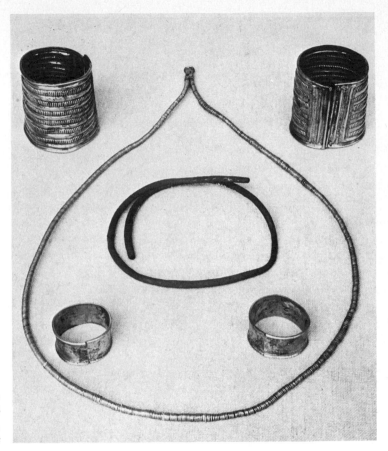

3 Gold hoard, including necklets and bracelets, Bronze Age

Other decorations at New Grange and Knowth vary considerably from this one. There are even primitive attempts at representational art, including the strangely distorted figure of an animal. But in general these early beginnings establish form and pattern and abstract balance as the basis, and it was to continue so, even after animals, birds, plants and human forms had superseded the simple geometric patterns of this early period.

The Bronze Age is rich in gold ornaments. Again the dating of *Ill. 3* these must remain speculative, but many have been placed with reasonable certainty at different periods of the time-span from 2000 BC down to the late Iron Age, and the finds in Ireland have been rich enough to give a quite clear idea of the developments in style and decoration from the early and very simple torcs and lunulae to the

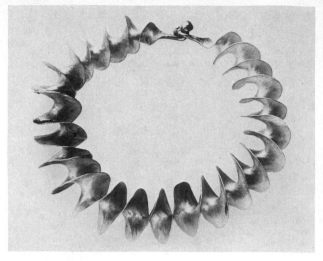

4 Celtic gold torc, late
Iron Age

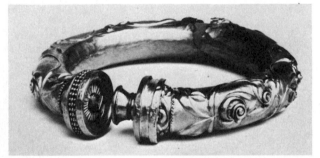

5 The Broighter Collar,
from the Broighter gold
hoard, first century AD

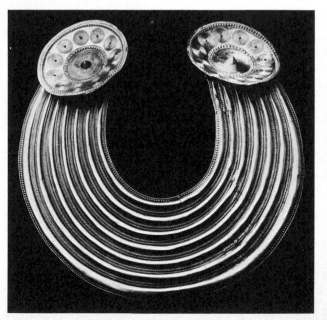

6 The Gleninsheen Gorget,
eighth century BC

12

complex design and craftsmanship of the Broighter Collar dating *Ill. 5*
from the first century AD, and showing, in its elliptical curves and
spirals and the depth of the relief work, close relationship with the
style of La Tène, the late Iron Age Celtic era, regarded by many as the *Ill. 4*
true fountain-head of Celtic art. The earliest of these ornaments are
very simple. The gold is plain, sometimes twisted into a spiral, and the
catch to fasten these early torcs round the neck is nothing more than
two lumps of gold at the ends which shoulder into one another. It is
only much later that such elaborate clasps as the one on the collar
which adorns the Roman marble effigy of *The Dying Gaul*, close in
style to the Broighter Collar, were introduced. Restrained decoration
in the form of geometric patterns, particularly around the borders
and at the tips of the lunulae and on other ornaments, including the
gold discs found in various places in Ireland, first appear around 1800
BC. There is not enough material to show us quite how the
elaboration of craftsmanship and design progressed, but a thousand
years later, at the beginning of the Iron Age, the same basic collar
design has changed radically. The craftsmanship of the Glenisheen *Ill. 6*
Gorget is of a high order. The points have been replaced by discs,
profusely patterned with smaller circles in a strictly geometric design,
and the lines and zig-zags cut into the surfaces of the earlier collars
have given way to plain carefully ridged curves, alternating with
gadrooned rims of a very high quality.

The Gleninsheen Gorget does not, however, display any of the *Ill. 6*
highly distinctive design associated with La Tène and apparent in the
Broighter Collar, and it is reasonable to assume that the most *Ill. 5*
significant Celtic wave of all arrived in Ireland at a later period during
the Iron Age, possibly as a result of the Gallic Wars and the growing
pressures of Roman civilization.

The Turoe Stone in County Galway shows close affinities in its *Ill. 7*
spiral and elliptical decorations with the designs on the Broighter
Collar, and, in all probability, belongs to the La Tène period. It is *Ill. 5*
quite small, less than five feet high, and its true purpose is unknown,
though it was probably a religious cult object. What is interesting is
that the sculptor who decorated it maintained his distinctive style of
ornamentation with a well-developed sense of balance and form and a
considerable awareness of the three-dimensional effect he wished
finally to achieve.

Art in Ireland during the pagan period remains a rich but very
puzzling heritage. Its beginnings are obscure, and without the sharp

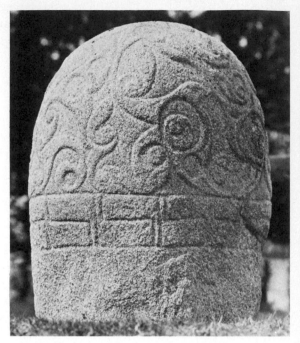

7 The Turoe Stone
(Co. Galway),
La Tène period

interruption of a Roman invasion, so pervasive an influence in Britain, and with the limited evidence at our disposal, even the later centuries which ushered in the Christian era with the coming of Saint Patrick, are shrouded in relative obscurity.

Christianity brought to Ireland in the fifth century conditions under which art could develop and flourish. It brought a central and most powerful belief round which the many and diverse facets of pagan art could be unified and re-directed, and the peaceful nature of the conversion of Ireland did nothing to alienate the highly developed Celtic society and culture, which in its Christian form was to survive for another five hundred years. To begin with, the monastic settlements were humble and primitive in the extreme. But they flourished on the merits of their teaching, and they grew and spread rapidly through the land until king and bishop stood side by side. The new medieval duality of church and state became an established part of the Irish social framework.

While it is not possible to deal in detail with the structure of Irish society at this time, certain aspects of it need to be understood if the art

produced by the country is to be seen in its true perspective. Celtic society was rural and tribal. There were no cities and no walled towns. The territorial unit was a small one, and was ruled by a king who might also have supremacy over the kings of neighbouring tribes, although this would not give him sovereignty over the people of such tribes. Eventually this structure led to the highest class of king known to the laws: the king of a province. The idea of a single king of Ireland is a relatively late one. It was probably first claimed by Niall of the Nine Hostages as late as the fifth century, during the first quarter of which he reigned. The claim to an Irish monarchy was certainly perpetuated by his descendants for six centuries afterwards, but theirs was quite often a theoretical rather than an actual supremacy.

Within each kingdom – and there were many, and they were small – there existed a quite strict hierarchy upon which many aspects of the law were based. At its top stood the king, tracing his right to kingship back through many generations to one or other of the ancestral deities. Next to him were the various degrees of nobility, the aristocracy or warrior class, those whose family trees were preserved among the genealogies and those of gentle birth. Whether there was much variation among the nobility beyond the natural one of wealth is open to question. Between them and the commoners there was a special, professional class of men whose skills gave them a status beyond the one to which they were born. They were called *aes dana* – 'men of art' – and as well as poets, historians, musicians, lawyers and other skilled or highly trained men, they included those responsible for the early works of art discussed in this history. They form the most interesting of the social orders in early Irish society, and while they are placed between the nobility and the commoner, they are much closer to the former, with a powerful voice and an influential position.

Another aspect of this early Irish society, and an important one where the laws of the land were concerned, was the fact that the unit of society was not the individual, but the kin. The smallest kin-group recognized by society was a four-generation group. This was the normal property-owning unit, and it was as a group responsible for the liabilities of its members. The law was concerned with inter-group matters rather than with the internal affairs of kindred.

Such a society does not construct for itself the kind of institutions which were introduced into Britain as a result of the Roman invasion. To take one basic example: early Irish society had no need for efficient roads. Throughout the country the tribal system was a

ciosely interwoven one: but it knew no centre, and required no general communications system. There were no cities to go to. Trade was effected by barter. Kingdoms were independent of each other, or where they were interdependent the balance was a fairly equal one.

But if much of the sophisticated development of the intricate structure of a nation or a state in the modern sense of the word was not undertaken by early Irish society, there was no reason why such a society should not be capable of producing great art and literature. The privileged position enjoyed by the artist and craftsman would have been envied by his equivalent in Europe during the eighteenth century. The system of patronage, together with the privileges accorded to ability, both technical and intellectual, did in fact produce works of art and literature of the highest order.

The coming of Christianity in the fifth century did not alter this social structure to any profound degree. If anything, the beliefs were absorbed by the society and adapted to their own needs. Certainly, within the four centuries between the beginning of the Christian mission to Ireland and the coming of the Vikings, much of the known fabric of society in the country remained surprisingly unchanged, and it was short-term Viking militance rather than four centuries of Christian influence from Rome that imposed upon the country so elementary a thing as the idea of a city.

No clear picture is possible. Much of what is said about Irish society at this time is highly speculative. Where the Celtic world is concerned scholarship still stands very much on the threshold, and in many respects this will always remain so. The works of art which have come down to us are themselves enigmatic. We know their quality; in most cases we know their function; and we know certain aspects of the society which produced them. But the contact we achieve through them with the society which produced them is often broken by fundamental gaps in our knowledge and understanding.

Although the conversion of Ireland began in the fifth century, it is not really until the middle of the seventh century that the astonishing sequence of masterpieces of early Christian Celtic art in Ireland commenced. Nevertheless the period from AD 432 up to the first years of the seventh century produced important and distinctive prototypes for the later flowering. They include many bronze objects, some with enamel work, the earliest engraved stone slabs, and the 'Cathach', a copy of the Psalms preserved in the Royal Irish Academy, and traditionally ascribed to Saint Columba.

8 The 'Petrie Crown', bronze tomb decoration

Perhaps the most famous and most elaborate of these early metal objects is the 'Petrie Crown', a bronze tomb decoration. The relief work in the metal is open and assured. The design, made up of elliptical curves and scrolls, is well balanced; and while the highly stylized head of a beast is used as part of the design, the overall effect is abstract and austerely simple. Some of the earlier penannular brooches belong to this period, and most of them show Roman influence in the design. But while the indirect influence of the Roman empire, which had so changed the society across the Irish Sea, made itself felt in various ways, Ireland was also open to, and received, artistic impulses from many other sources including Egypt, Syria, Greece, Armenia, perhaps even Persia.

Ill. 8

The earliest stone sculpture follows the pagan style of decoration without any attempt to shape the stone. Flat engraved slabs bear simple designs of the cross, often within a circle, and with various extensions of the design around or underneath. Only at the end of the sixth century does the cross actually emerge from the slab as a carved shape, one of the earliest examples of this being the crude but vigorous Carndonagh Cross in Donegal. This monument, while its outline is unrefined, has a fascinating wealth of carving on it, from the intricate interweavings which cover the top, the animals and birds which lurk in corners of the design, to the round-faced, simple but

Ill. 9

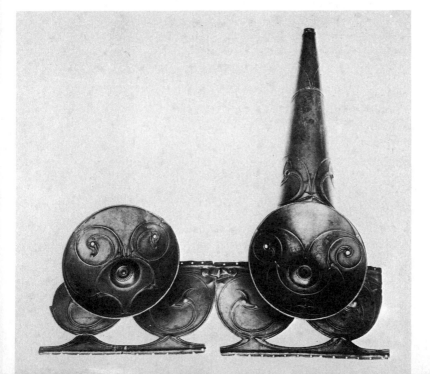

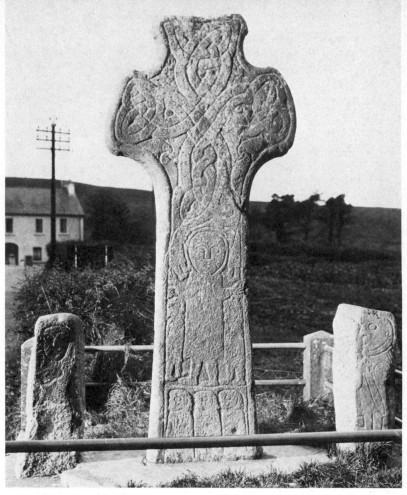

9 The Carndonagh Cross (Co. Donegal), late sixth century

pious figure standing beneath with arms outstretched in a universal benediction.

With the seventh century technical perfection and a stylistic independence brought about a synthesis in the art of metalwork, sculpture and manuscript illumination, and a sequence of Celtic masterpieces in each of these spheres began.

One of the earliest and finest of the illuminated manuscripts is the *Ills. 10, 11, 18* Book of Durrow. It is a copy of the Gospels, and came originally from the monastery founded in Durrow, County Offaly, by Saint Columba. It was for a time in the possession of a farmer who used to

dip it in the drinking water used by his cattle as a cure for disease. It passed eventually into the hands of the Cromwellian Bishop of Meath who presented it to the Trinity College Library.

The book is smaller in page size than most of the other Irish illuminated manuscripts, and employs a relatively limited range of colours in the decoration – strong red, bright yellow and dark green. The outlines to the drawings and the backgrounds to the interlacings are in dark brown, probably black when first done. The text, which is the Latin Vulgate, is done in Irish majuscule, and the initial letter and opening lines of Saint Mark's Gospel display certain distinctive characteristics of the Book of Durrow. One is the use of dots to give a field of colour without making the effect too solid. Dots are also used to emphasize outline, as in the smaller initial letters, and to add colour without too much boldness to the main decoration. The initial N is *Ill. 10* abstract in design, relying primarily on panels of interweaving and spirals. The abstract nature of the design is maintained throughout the book. Only rarely, as at the beginning of the Gospel of Saint John, do

10 Book of Durrow, initial page of Saint Mark's Gospel, seventh century

11 Book of Durrow, Evangelist's symbol of Saint Mark, seventh century

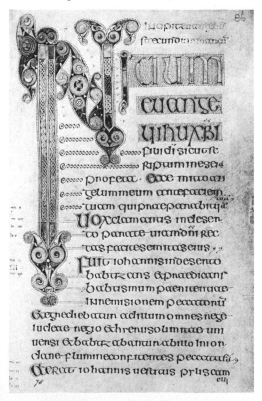

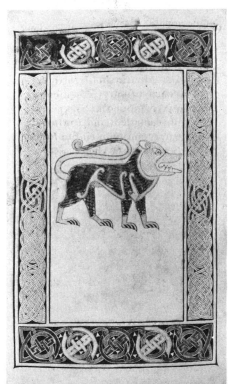

the involved interlacings turn from abstract ribbons of colour into elongated and strangely contorted beasts, their jaws locked into their own or another's flesh, their bodies woven into patterns of ordered distortion and subtle balance which stand out with an almost fierce intensity of colour from the dark background.

But the finest pages of all are those depicting the symbols of the four Apostles. In them the artist has displayed immense range of understanding of the value of contrast, the use of white space, the modulation of colour by using dots and lines, and the considerable *Ill. 11* potential of his limited palette. In the symbol page for Saint Mark's Gospel the highly stylized and ferocious lion stands in profile, his body outlined in yellow and covered in a pattern of red and green diamonds, his head, with its staring yellow eye, a far from haphazard carpet of red dots which emphasize the formal and stylized nature of the drawing and modify the contrast between the beast and its background of plain cream-coloured vellum. The simple border to the page is made up of four panels of interlacings, the side ones narrow and involved, but made light in overall effect by the use of dots, the top and bottom panels much stronger, with solid colouring, more dark brown background visible and a design of greater simplicity and boldness which holds the page together.

The book is difficult to date, and some aspects of it have long been the subject of academic controversy. There are Saxon influences in the design, there are visual relationships with decorations on the *Ills. 9, 13, 14* Carndonagh Cross, the Tara Brooch and the Ardagh Chalice, and the relationship with Lindisfarne, from which another of the great *Ills. 16, 17* illuminated manuscripts of the period originated, is explained by the fact that both monasteries were Columban. While it is highly accomplished in its craftsmanship and technique, the artistic conception is comparatively simple and experimental in both colour and design. There are none of the sophisticated flights of the *Ills. 21–3* imagination which characterize such manuscripts as the Book of Kells, and in this lies much of the strength and delight of the earlier work.

Ills. 10, 11, 18 The best qualities of the Book of Durrow, the restraint, the balance, the formal dignity, the exuberant but disciplined imagination, are epitomized in the finest example of Irish metalwork of the *Ill. 14* early Christian period, the Ardagh Chalice. Mlle Françoise Henry, in her *Irish Art in the Early Christian Period*, says 'the whole balance of the composition has still the strength and restraint of the best seventh-

century work and belongs to that moment of perfection that marks the turning point between a youthful, impetuous, though already experienced art, and a surfeited and over-elaborate decoration.' The parallel between the two works is quite close. Much of the surface area of silver is quite plain, and this serves to emphasize the richness, brilliance and intricacy of the panels of gold filigree and the red and blue glass studs which cluster below the handles and divide up the panels of decoration. The chalice has a plain rim, reinforced with brass. Below it there is a broad band divided by glass studs into ten panels, all of which are decorated in the most delicate and complex gold filigree work. The design of each of the studs is based on the cross. The names of the Apostles are lightly engraved in the silver below this band of gold panelling, and then in the centre of each side is another cross, simple in its basic design, but richly decorated, again with glass studs and gold filigree work, and employing fairly simple spiral patterns. The bowl of the chalice is joined to its base by a thick bronze stem, heavily gilt, and worked in the most intricate and involved of all the decorations on the cup. The other concentration of rich colour and pattern occurs at each of the handles. These are decorated with coloured glass panels in red, blue, green and yellow interspersed with tiny frames of gold filigree work of great craftsmanship and complexity. The concentrations of gold and glass are outlined on the plain surface of the silver with lines and dots, and the panels and particularly the studs of glass are heavily embossed, the main ones standing out more than half an inch from the surface of the silver bowl. In the originality of its overall conception, in the working of the silver and gold, in the manipulation of moulded, coloured glass, in the simple, light engraved work on the silvery-grey metal, the Ardagh Chalice stands out as a supreme example of early *Ill. 14* Irish art at its best. And it was found just one hundred years ago by a young boy who was digging in a field of potatoes at Ardagh, County Limerick. With it was a smaller bronze chalice and four penannular brooches, all of them now in the National Museum, Dublin.

The form of these penannular brooches, while they have always been regarded as peculiarly Irish, and have acted as a somewhat baleful influence on jewellery and design down to the present day, derives from a design that is basically Roman. There are numerous examples, varying considerably in style and in workmanship. They have no specifically Christian significance, and are as likely to have formed part of the personal adornment of kings or queens as of

bishops of the church. The finest of them all, the Tara Brooch, is
unusually close in style to the Ardagh Chalice. It has no connection
with Tara, the seat of the High Kings of Ireland, and was in fact found
in a wooden box near the mouth of the River Boyne, along with
other objects, in all probability abandoned loot. It is one of the
smallest of these brooches, and certainly the finest and richest example
of Celtic jewellery to come down to us. It consists of a closed ring in
cast silver with an ornamental pin attached by a loose ring; there is a
silver mesh chain attached to one side, and it is assumed that the
brooch is one of a pair, originally joined together across the shoulders.
Both the front and the back are decorated. The casting of the front is
in the form of deep open panels into which gold filigree work, close in

Ill. 14 style to the work on the Ardagh Chalice, was inset. A number of these
panels are now empty, but the remaining examples reveal a
remarkable delicacy and fineness of work, and a highly original
inspiration. Beasts with pronounced eyes and lips curl and intertwine
in raised threads of gold within spaces that at times are no more than
quarter of an inch square; and the abstract decoration has an
inexhaustible variety. At key points in the design there are glass and
amber studs, some of them crowned with filigree work and gold
granulation. Copper has been used in the larger panels, and it adds to
the range of colour produced by the gold and the silver. The back of
the brooch lacks the depth and relief effect of the front, but is equally
rich in design, and is even closer in the style of the glass studding to the

Ill. 14 same decorative feature on the Ardagh Chalice. It belongs to the same
period, and may conceivably have come from the same workshop,
even from the hand of the same anonymous craftsman. Certainly the
outstanding quality of brooch and chalice which raises them so firmly
above other similar discoveries also draws them closer together, and
that is as much as one is able to say with any certainty.

There are other important examples of monastic art from this
Ill. 12 period. The origins of the Saint John's Crucifixion Plaque are
probably quite different from those of the brooch and chalice. It is one
of the earliest representations in Irish art of the Crucifixion, and dates
from the late seventh century. The central figure of Christ with arms
outstretched and nailed to the shaped cross resembles the figure on the
Ill. 9 Carndonagh Cross in Donegal, but much of the decoration, which
includes a herring-bone pattern, unusual spirals and zig-zags and
combinations of cross and circle, are not to be found elsewhere. The
plaque may have decorated a shrine or a book cover. The Moylough

12 Saint John's Crucifixion Plaque, late seventh century

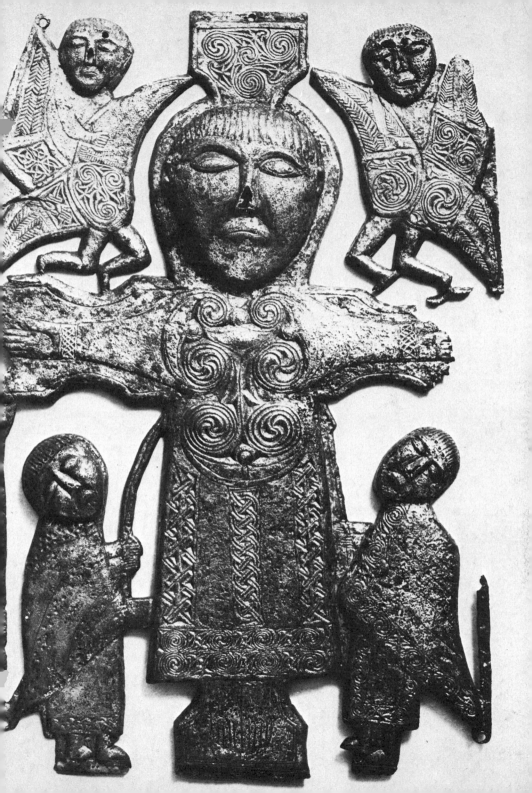

Belt Reliquary, a bronze shrine for a leather belt, probably that of a saint, is fairly close in style to the chalice, and rich in bird and animal representation done in the form of buckles and fasteners around the shrine. Less ornate but contemporary bells, brooches, altar vessels, reliquaries, bronze mounts and other early Christian examples of art survive, and their discovery throughout the country, coupled with their distinctive and homogeneous style, point to a richly organic tradition of which we are, today, the inheritors of only a tiny portion.

To understand the development of Irish art from the eighth century on, the expansion of Irish missionary activity into Scotland and England must be appreciated. Whereas the early art displays a remarkable unity of design and inspiration, the later art of the eighth and ninth centuries is modified in its styles and trends by the fact that monastic artists were working further and further away from their aesthetic roots, and were more and more open to influences within the countries they sought to convert, or to which they came with the offer of their sophisticated but highly individual skills. This is most effectively demonstrated in terms of Irish illuminated manuscripts. They are the most portable of relics, which is itself something of a disadvantage when it comes to tracing origin, but at the same time they are richly distinctive in style, impart considerable information through linguistics, calligraphy and their colophons, and have been the object of careful preservation – with notable exceptions – for a far longer period of time than has the sculpture, the metalwork or the jewellery. Just as nothing equals in its own sphere the powerful simplicity of the Book of Durrow, so nothing equals the richly complex and diverse range of the Book of Kells, written and illuminated little more than a century later. And between the two may be placed with reasonable assurance a wealth of illuminated Gospels and other devotional books, all of them derived from Irish artists, and including the Books of Dimma, Armagh, Mulling, Mac Regol, Saint Chad (also known as the Lichfield Gospels), the Lindisfarne Gospels, the Stowe Missal, the Saint Gall and the Echternach manuscripts.

The Book of Saint Chad, preserved now in Lichfield Cathedral, is an example of the 'wandering' manuscript. Its place of origin is not known, and the earliest mention of its movements is contained in some notes in Welsh on the manuscript itself, recording that it was exchanged for a horse, and subsequently given to Saint Teliau and placed in the monastery of Llandaff, near the Bristol Channel. This

Ills. 10, 11, 18
Ills. 21–3

Ill. 20

Ill. 19
Ill. 15

13 The Tara Brooch, early eighth century

14 The Ardagh Chalice, early eighth century

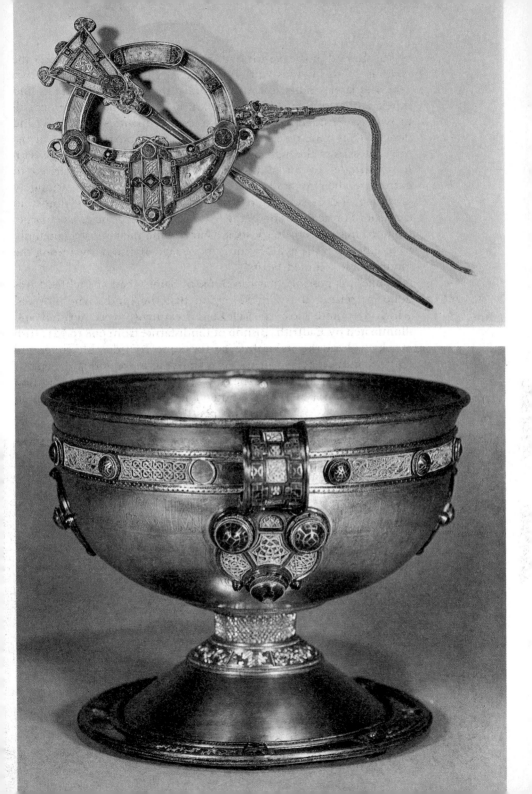

was at the end of the eighth century, up to a hundred years after the writing of the manuscript. It passed to Lichfield Cathedral two centuries later, and is still in the library there. It is incomplete and much damaged, particularly the colouring. But what is left to us still provides a considerable variety of styles, and qualities of drawing and design. They range from the relatively simple portrait pages of the four Apostles to the high sophistication of the ornamental page with its multitudes of birds and animals, their contortions carried to *Ill. 15* extremes, their overall effect florid and obtuse, but strangely satisfying and in concept remarkably original. There is almost an element of optical illusion in the way the outline of the cross emerges from the mass of scrolls, twists and curves, and then is lost again, only to re-emerge as the eye continues its voyage of discovery among the innumerable, tangled beasts.

While it is possible that the Book of Saint Chad at Lichfield was *Ills. 16, 17* done in Ireland, it is almost certain that the Lindisfarne Gospels, which are quite close in style and treatment, were written and illuminated by Eadfrith, Bishop of Lindisfarne, from 698 to 721. Irish monks had taught at Lindisfarne for some considerable time, and Eadfrith himself had spent six years studying in Ireland at the end of the seventh century, so that the closeness of this work to the tradition of Irish art is not really in dispute. The manuscript, which is in an

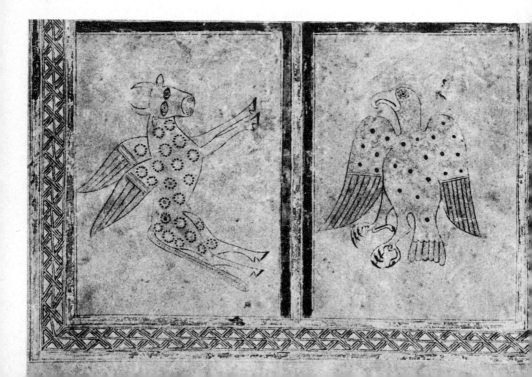

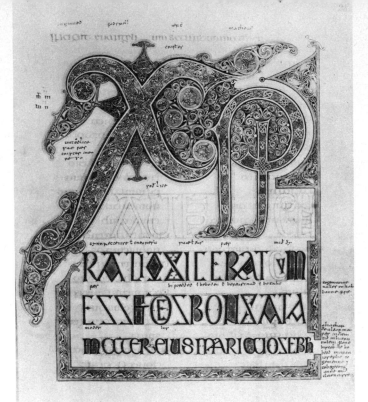

16 Lindisfarne Gospels, the Chi-Rho, late seventh century

excellent state of preservation, is in the British Museum. The range of colours used in the illustrations is extensive, with several shades of the principal blue, red and yellow. Influences on the style of the artist have broadened, and Mediterranean traits of a Greek or Byzantine origin are present, particularly in the portraits of the Apostles. But the Book of Lindisfarne is still essentially Irish, its decoration and its lettering revealing an amalgam of characteristics from various sources, much of the perverse animal decoration coming from the Book of Saint Chad, while the simpler devices, the interlacings, the dots and the spirals show direct descent from the Book of Durrow. Françoise Henry says of the Lindisfarne Gospels, 'The whole decoration is permeated by a sort of frozen perfection,' and in spite of its pristine condition and its aesthetic completeness and unity, one is inclined to agree. It is the work of a very gifted pupil of Irish teachers whose academic understanding is extensive, but whose deeper sympathies with the origins of the Celtic tradition in which he works are absent.

Ill. 15

Ills. 10, 11, 18

Ills. 16, 17

15 Lichfield Gospels, two symbols of the Evangelists, seventh century

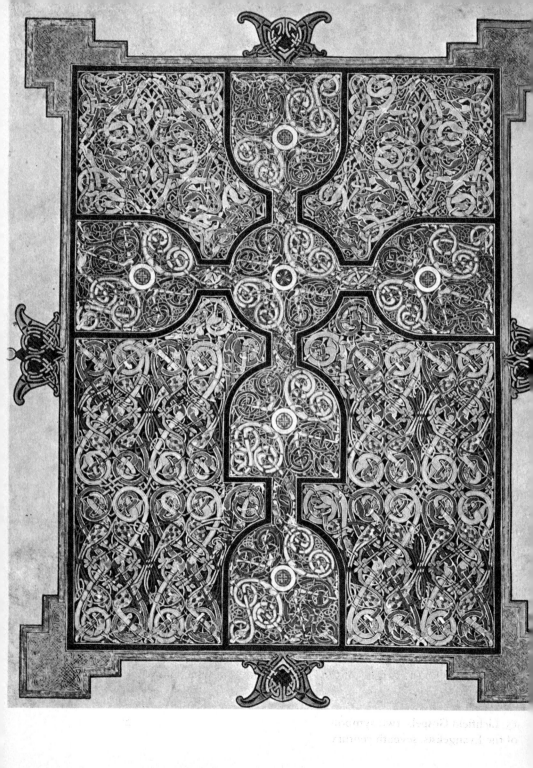

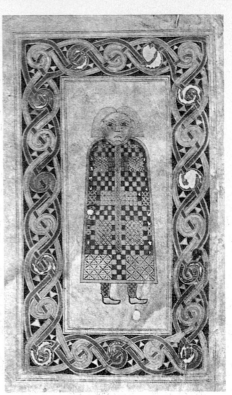

17 Lindisfarne Gospels, 'carpet page', late seventh century

18 Book of Durrow, Saint Matthew, seventh century

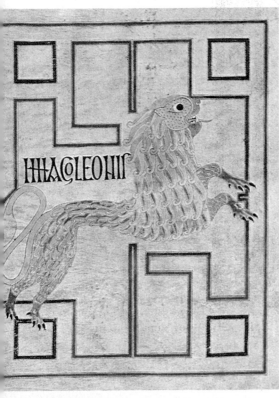

19 Echternach Gospels, symbol of Saint Mark, c. 690

As well as the large illuminated manuscripts, usually designed to rest on the altars, there are a number of much smaller books, with abbreviated texts, possibly made light so that they could be carried easily by bands of monks setting out on pilgrimages, or on missions to other kingdoms. One of the finest of these is the Book of Dimma in the Trinity College Library in Dublin. It is somewhat cruder in style than the larger books, but colourful and vigorous. It is the work of more than one scribe, and was written at the monastery in Roscrea, County Tipperary, probably towards the middle of the eighth century. In the planning of the illuminated pages, in its colour range, in the interlacings and the use of dots, it displays all the simpler strengths which make the Book of Durrow so fine an example of the art of this early period.

Ill. 20

Ills. 10, 11, 18

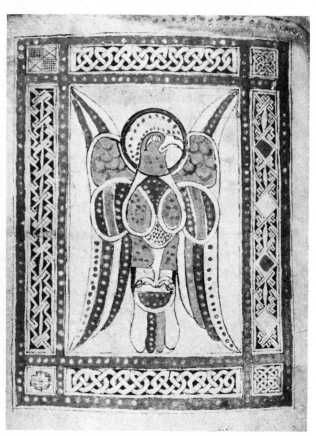

20 Book of Dimma, symbol of Saint John, seventh century

Three other small decorated manuscripts belong to the same period: the Stowe Manuscript in the Library of the Royal Irish Academy, the Book of Mulling, and a much restored but finely drawn Gospel fragment in the British Museum.

The supreme achievement of Irish Celtic art, however, is the Book of Kells, which probably dates from the second half of the eighth *Ills. 21–3* century. In it all the diverse strands and developments in Irish art seem to reach perfect fruition. It is strong and original in its design. Its range of colours and their use are intensely sophisticated. Its script is beautifully clear and rounded, and the decorations run through it, their wild and varied flights of imagination bringing colour and invention to the opening letters of sentences throughout the pages of text. Sometimes these decorations in the script assume the proportion of major illuminations, as in the treatment of the Beatitudes, in Saint Matthew's Gospel, where the whole length of the page is decorated with eight capital Bs, each of them formed out of serpent bodies, four with human heads, four with the heads of birds, all richly coloured in turquoise, violet and golden brown. At other times these decorations are small, obscure, and often surprisingly comic representations of insects, animals, birds and human figures, peering from behind letters, lurking in the corners of pages, floating between the lines or in the margins. Sometimes the figure of an angel or an Apostle peers over the top of one of the initial letters or decorative panels, and his feet jut out beneath. And yet these decorations do not impinge on the clear bold script, which runs on with smooth precision through the 339 leaves of the book which have survived. Only in the great illuminated pages is the emphasis reversed. In these portraits, Gospel scenes, full pages of ornament and introductory pages of decoration, the artist takes over with his balanced mixture of invention and discipline. His range of colours is considerable. It includes the frequent use of different shades of mauve, several shades of yellow, blue, brown, green and red. His sense of space and balance on the page is excellent, and the range of design and symbol embodies all the discoveries of the earlier artists known to us from other books from Irish monasteries. But there is something more which raises the Book of Kells to its pre-eminent position, something that makes of it a *Ills. 21–3* perfect work of art in spite of conflicting styles, unfinished pages and uneven quality. It is not easily defined, but is perhaps best explained by the fact that the central element in the wide range of decoration and ornament in the Book of Kells is Man. The earlier abstract

designs, the spirals, the interlacings, the woven patterns and the dots are there; the later foliage, and the richly diverse Celtic bestiary are also there; but instead of being central, as in the many manuscripts so far considered, they now all revolve around the figure of Man. Man is presented as Christ, as Angel, as Apostle, as Devil, or as mere

Ill. 23 onlooker in a scene, such as the Temptation of Christ or His arrest in the Garden of Gethsemane; but the essential human involvement, leading to the full response of emotion and intellect, which is and must be part of any great work of art, is present in the Book of Kells. Man gives to the animals, the birds, the insects, the flowers, the abstract patterns a unity and a cohesion which is overwhelming in its impact. All these varied elements in the illuminator's imagination, drawn from the environment in which he and the other monks of Kells lived and worked, are drawn together by the dominant symbol of Man.

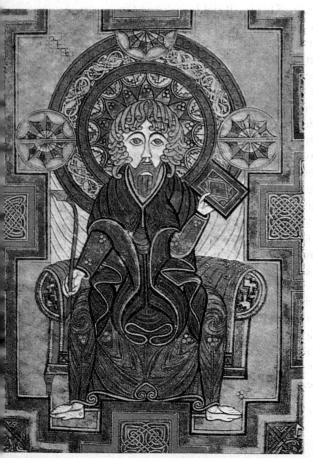

21 Book of Kells, Evangelist, early ninth century

22 Book of Kells, Virgin and Child, early ninth century

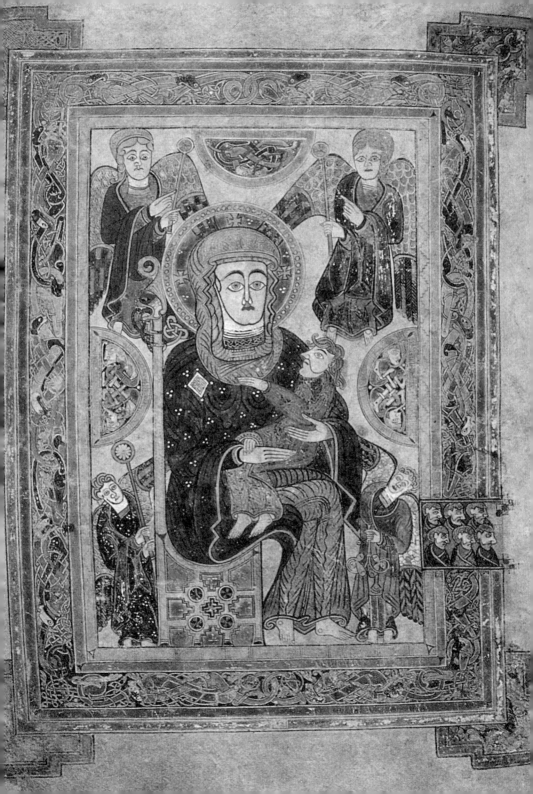

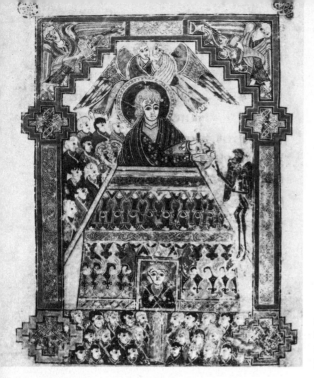

23 Book of Kells, the Devil tempting Christ to cast Himself down from the Temple, illumination to Saint Luke, early ninth century

In the Temptation of Christ this sense the artist has of human tension and human destiny provides him with a dramatic picture of the confrontation of Christ and the Devil. In the 'Portrait' of Saint John, on the other hand, the subject is serene and icon-like, the object of veneration and devotion, and any tension there is would be established between this emblem of a Saint and the monks who gazed upon it.

The Book of Kells had a somewhat chequered history. It was stolen in 1007, the gold taken from the shrine in which it was kept, and the book buried 'under a sod'. At the time of the Reformation it was surrendered to the Crown, but before long passed into the hands of Archbishop Ussher, who presented it to Trinity College. It was already defective then, and the book as it stands is in an incomplete state. Yet it is still the richest and most varied of all Irish treasures from the period of Celtic art, and in all its variety and richness of ornament, colour, design, decoration, the very creative imaginations of its *Ills. 21–3* scribes and artists, the Book of Kells is itself a concentrated synthesis of those qualities which P. Jacobsthal saw in all the art of the Celtic realms:

34

... their art also is full of contrasts. It is attractive and repellent; it is far from primitiveness and simplicity; it is refined in thought and technique, elaborate and clever, full of paradoxes, restless, puzzlingly ambiguous; rational and irrational; dark and uncanny – far from the lovable humanity and transparence of Greek art. Yet it is a real style, the first great contribution by the Barbarians to European art, the first great chapter in the everlasting contacts of southern, northern and eastern forces in the life of Europe.

The origins of Celtic art will remain obscure. In its earliest phases it seems to be the abstract expression of man's awareness of himself and his own tangible environment. He is the centre of his own world, and his basic motif is the circle. Then, with the La Tène period, new impulses come in. Perhaps there is Scythian influence on Celtic art. Perhaps there is a very real link between the art which the Scythians brought with them, over a period of generations, from the Khingan Mountains in Mongolia right across Asia to the shores of the Black Sea and the valley of the Danube, there to pass on their rich sense of colour, their obsession with animal symbols in their art, to the easternmost, Hungarian fringes of the Celtic world. Certainly the discoveries at Pazyryk would endorse such a view, even if it must always remain highly conjectural. From then on, even if the influences of Roman, Greek, Byzantine, Scandinavian and North African art can increasingly be detected, the development through the early Christian period continues to be one of puzzle and paradox, right up to the peak of Celtic creativity in the eighth and ninth centuries. With the Viking invasion of the mid-ninth century there comes a kind of watershed. The invasion, which was spread over two distinct periods, has been shown in various lights by different historians. As far as art is concerned it can be fairly clearly stated that the destructive and disruptive nature of the prolonged attacks was in no sense total, and the Viking invasion does not represent an unbridgeable chasm. On the other hand, for close on a century and a half there was pillage and destruction throughout the country, and whatever recovery followed in the eleventh and twelfth centuries, the unique structure which had produced the Book of Kells and the *Ills. 21–3* Ardagh Chalice was replaced by a very different one in which war *Ill. 14* and bloodshed, with their attendant anxieties and tensions, were to become an increasingly frequent feature.

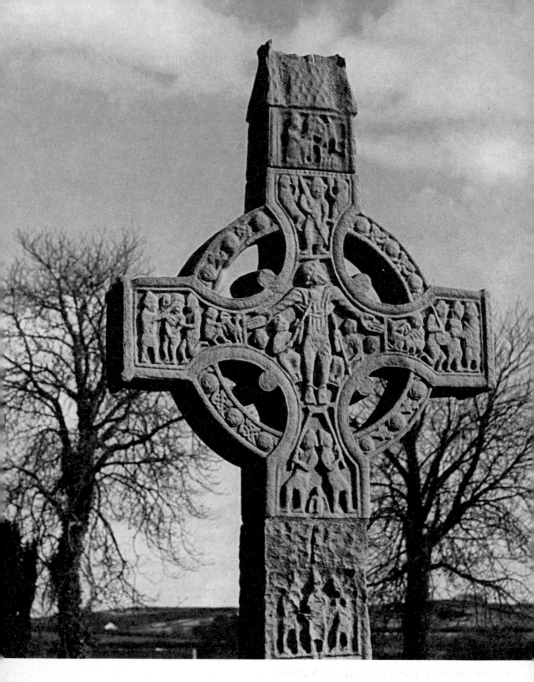

24 The Cross of Muiredach (Monasterboice, Co. Louth), 923 A D

From the Viking invasion to 1700

The Viking invasion of Ireland did not only disrupt the long period of peaceful development in Irish art. It also ushered in close to eight centuries of invasion, civil war, repression, siege, religious intolerance and tyranny. Art suffered first by being either the object of the pagan greed of the Norse invaders, or the victim of their widespread destruction and desecration. But it continued to suffer far more profoundly after the defeat of the Norsemen at the Battle of Clontarf in 1014, due to the fragmentation of Irish society, and the introduction, with the Norman invasion of 1170, of the fundamental and long-lived division of the country into an Anglo-Irish Pale, centred on Dublin, and a Celtic hinterland, with local rulers, usually in dispute with each other or with their Norman or Plantagenet or Tudor rulers. The art of a nation can survive invasion. It can even survive destruction, so long as the artists themselves survive and re-establish themselves and the stable environment needed for their work. But if that environment itself is destroyed or broken up, then the artist becomes isolated and his sense of social involvement and obligation disappears. Any national tradition will disappear, too. Irish art in this period becomes increasingly meagre and fragmentary. Its only continuity is an historic one, and in its wide range of styles, the diverse influences that become apparent, and in its eventual shift from religious to secular environments it reflects the continuous and turbulent evolution of a new and very different society in the country.

The Viking invasions were not, of themselves, sufficient to destroy Celtic art. They began in the mid-ninth century. For a period of forty years, from 875 to 915, there was relative peace, but then the pillage and destruction became widespread throughout the country for almost a century, finally being ended by Brian Boru at Clontarf in 1014. When the invasions began, Ireland already had one very durable art form which was to survive much of the desolation: its sculpture in stone. Already, during the eighth century, the high crosses had developed very considerably from the early simplicity of the Carndonagh Cross in Donegal. The South Cross, Ahenny, is an *Ills. 9, 25*

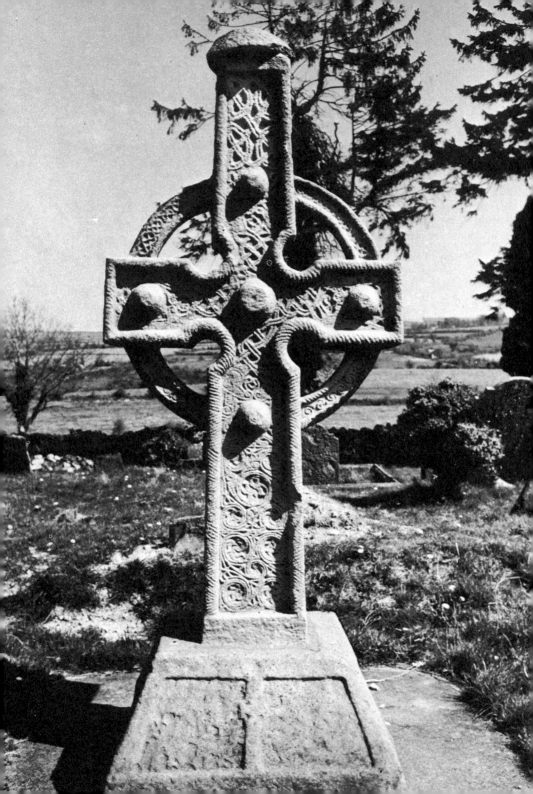

elaborate work, deeply carved with spirals and interlacings, its outline a pronounced ridge of gadrooning and the point of intersection of the four arms strongly emphasized by semicircular indentations. The decoration is for the most part abstract, being in the form of interlacings and spirals, though with some animal representation. Such Biblical scenes as there were on the base of the cross have been considerably weathered, but there is almost certainly the representation of the Lions' Den and possibly of Noah's Ark. In spite of this the cross remains one of the most distinctive of all Irish high crosses, its strong outline emphasized by the wheel-head, and the subtlety of the carving emphasized by the deep, bold outline and the depth of the panels of the cross inside its frame.

It belongs to pre-Viking Ireland. Yet it stands at the beginning of a considerable development of style and technique in sculptured high crosses which can be traced through the ninth and tenth centuries, which survived the Norse incursions, and which probably provided the later period of Celtic art, during the eleventh and twelfth centuries, with much-needed inspiration. One of these, the Cross of Muiredach at Monasterboice, has been dated by its inscription to 923, *Ill. 24* and others are closely related. Perhaps the finest is the Cross of Moone *Ills. 26–8* in County Kildare. Its stately appearance contrasts vigorously with the crude and bold carvings of Biblical scenes and figures. Its height is stressed by the smallness of the wheel-head cross at the top, and by the extended pyramid shape of the base. Yet into this graceful framework a teeming world of activity and vitality has been carved by the unknown sculptor. One magnificent panel at the base of the cross

25 The South Cross (Ahenny, Co. Tipperary), eighth century

26 The Cross of Moone, detail, Flight into Egypt

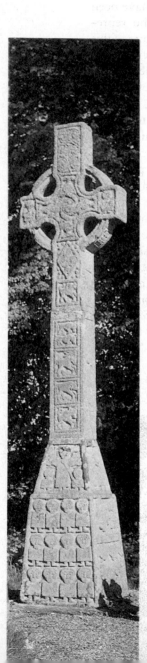

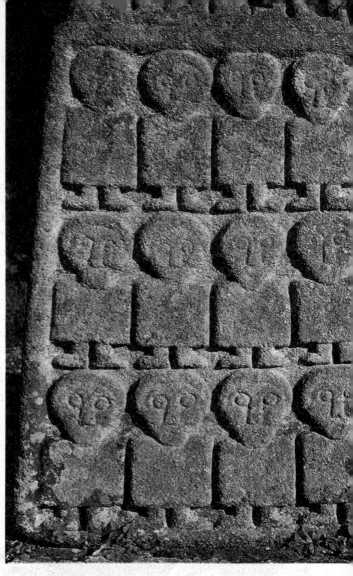

27 The Cross of Moone
(Ballitore, Co. Kildare),
ninth century

28 The Cross of Moone,
detail of the base

contains the twelve Apostles in rows of four, strictly stylized and uniform, their bodies square, their feet turned out, and their faces, wide-eyed and innocent, strangely comic in their sameness of expression. Many scenes are depicted in the panels on the four sides of the cross, including the Temptation of Saint Anthony, the Flight into Egypt and the Figures in the Fiery Furnace. Some panels contain straightforward representations of animals while others revert to the spirals and patterns of earlier decoration. The style adopted by the sculptor is highly distinctive, and the formalized simplicity, an innocent, almost childlike quality, gives to the complete work great unity and strength.

There may have been a break, during the second period of Viking raids, in the sequence of development in the sculpture of Irish high crosses. The last group of all, which includes the very fine cross at Drumcliff in County Sligo, overlooking the grave of the Irish poet, W. B. Yeats, and crosses at Roscrea in County Tipperary, Tuam in County Galway and Kilfenora in County Clare, show further stylistic change and development, and belong to the period of resurgent Celtic Christianity in the eleventh and twelfth centuries which preceded the arrival of the Normans.

To this period, too, belong many fine crosiers, shrines, crosses and other religious jewellery, as well as some of the more notable architecture, such as the abbeys at Mellifont, Jerpoint, Cashel and Boyle.

The Shrine of Saint Patrick's Bell was made in about 1100 by order of Donal O'Loughlin, King of Ireland (1088–1121), to enshrine the relic of Saint Patrick known as the Bell of the Will. The shrine is made of bronze, with gold and silver interlacings in its panels, many of them incorporating animal designs. Large crystal and coloured glass bosses decorate the sides, and at each end the handles are surrounded by ornate filigree tracery. The style echoes the technique used in the Ardagh Chalice and the Tara Brooch, where panels of silver or bronze were deep enough to contain the richer and far finer gold filigree decoration. The shrine is by no means as intricate as those earlier creations, but it does have a pleasing unity of design, and in places, as in the working of the beady-eyed birds at the top, displays considerable originality.

A number of crosiers from the eleventh and twelfth centuries have survived. Some are only fragments, others are remarkably well-preserved. The Lismore Crosier dates from the beginning of the

29 The Lismore Crosier, early twelfth century

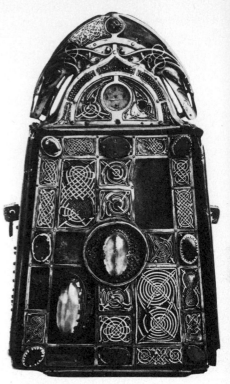

30 Shrine of
Saint Patrick's Bell, *c.* 1100

Ill. 29

Ills. 31, 32

twelfth century and is inscribed with a prayer for Niall, who was Bishop of Lismore, in County Waterford, from 1090 to 1113. The shaft and the crook are of bronze, with decorative panels which at one time probably held filigree designs in gold. There are coloured glass studs on the shaft with cross designs on them, and much of the surface of the crosier was at one time heavily gilded. The curved back of the crook has an openwork crest of animals, intertwined, and with interlacing between them. The crest terminates in the head of an animal at the back, and on the other side of the shaft there is a gilded human head, possibly representing the bishop for whom the crosier was made.

The most glorious creation of this period, however, is the Cross of Cong, which in many of its details recaptures some of the best qualities of eighth-century Celtic art. The cross is a shrine for a fragment of the True Cross, and was made in about 1123 on the orders of the High King of Ireland, Turlough O'Connor. It has various inscriptions, one of the most interesting being a reference to the craftsman who made the cross, Maelisu. It is, in fact, remarkable

42

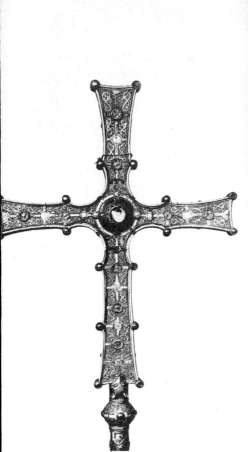

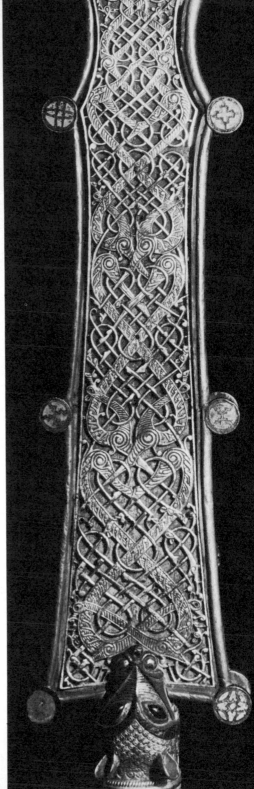

31 MAELISU The Cross of Cong, *c.* 1123

32 The Cross of Cong, detail of the shaft

that the four names related together by the four inscriptions should be those of the king, two bishops and the artist. Yet nothing more is known of Maelisu, and no other work from his inspired hands is recorded.

Ills. 31, 32

The cross is of oak cased in copper and silver, and with decorations in gold and gilt bronze. In the centre, and raised from the surface of the cross, is a large quartz crystal behind which the relic was probably encased. But the most striking feature is the point at which the cross is joined to the shaft. The shaft terminates in a large boss decorated with panels of filigree, glass insets and enamel. Out of the top of the boss there emerges a grotesque head which grasps the base of the cross in its teeth. It is a two-sided head, with eyes and prominent ears on both top and bottom, and richly decorated with patterns of scales, spirals and lines. It is the most distinct single feature of the cross, and a remarkable tribute, after a development over many centuries, to the strength of the animal motif in Celtic art in Ireland.

Ill. 15

The whole of the front of the Cross of Cong is divided into panels, each filled with gold filigree patterns employing animal designs. These are subtle and delicate, and in some ways quite close to the animal interlacings in the ornamental page of the Lichfield Gospels. At key points between the panels, and around the outside of the cross, there are small glass and enamel bosses. The sides are covered in silver, and the back of the cross had four long panels of bronze animal interlacings, one of which is now missing. The various inscriptions are engraved in the silver sides of the cross.

In spite of the richness of ornamentation, however, the overall effect of the cross is sombre, even a bit austere. The focus of attention is the single 'eye' of rock crystal, and the balance is such that all other elements are subordinate. This is natural enough. The art reflects a more sophisticated community with a more carefully worked out scale of values. The rich and sometimes riotous profusion of an earlier age has been scaled down and disciplined, and if it has lost some originality it has, at the same time, gained in formal consistency and control.

Ills. 31, 32

The new sophistication in the structure of Irish communities, with their balanced amalgamation of church and state, the king and bishop whose names are recorded, along with that of the artist, on the Cross of Cong, is reflected in the architecture of the period. While the Viking invasions can be regarded as a profound interruption, and the first of many, they were followed, it must be remembered, by a

44

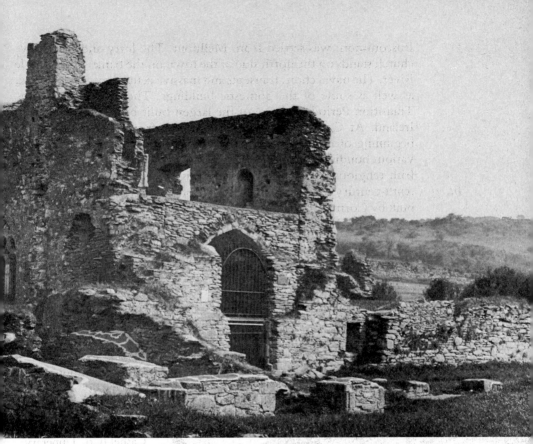

33 Mellifont Abbey ruin, general view, founded 1142

period of relative peace from Brian Boru's victory over the Norsemen in 1014 up to the Norman invasion in 1170, a space of more than 150 years. During that time religious communities of considerable size and influence were established, and the churches which they built are fine and impressive, often surrounded by extensive community buildings, and by the characteristic Round Towers, although these are often of earlier date.

Mellifont Abbey was the earliest of the Cistercian Houses in Ireland. It was founded by Donagh O'Carroll, King of Oriel, in 1142, and the consecration of the abbey church was attended by Gelasius, the Irish Primate, and by the Papal Legate, Cardinal Paparo, as well as by seventeen bishops and lay leaders from all parts of the country. Four years after the consecration, Boyle Abbey, in County

Ill. 33

Ill. 34

Roscommon, was settled from Mellifont. The lofty and impressive church stands on the north side of the town on the banks of the Boyle River. The nave, choir, transepts and massive central tower still stand, as well as some of the domestic buildings. The building is of the Transition Period, and one of the largest built by the Cistercians in Ireland. At Cashel, in County Tipperary, from the fourth to the beginning of the twelfth century the seat of the Kings of Munster, various buildings and ruins bear witness to the chequered fortunes of Irish religious communities during this period. The site contains a *Ill. 35* tenth-century tower in perfect condition, the twelfth-century chapel built by Cormac, King-Bishop of Cashel from 1122 to 1138, the ruins of a cathedral built in 1169, the late eleventh-century Cross of Saint Patrick and various fourteenth- and fifteenth-century additions. Close to the Rock of Cashel, on which these ruins stand, there is a thirteenth-century Dominican friary, and Hore Abbey, a thirteenth-century Cistercian House, again settled from Mellifont in 1266.

Mellifont was also the place chosen by King Henry II, on his visit to Ireland in 1172, to receive the homage of the northern chiefs. The

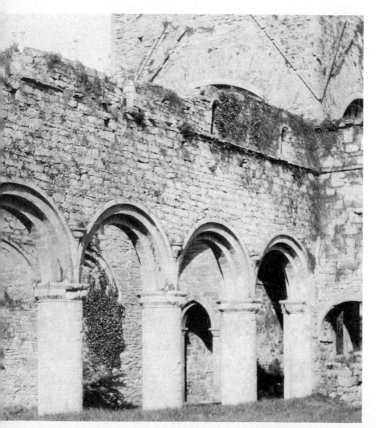

34 Boyle Abbey
(Co. Roscommon),
founded 1146

35 Cormac's Chapel,
Cashel (Co. Tipperary),
consecrated 1134

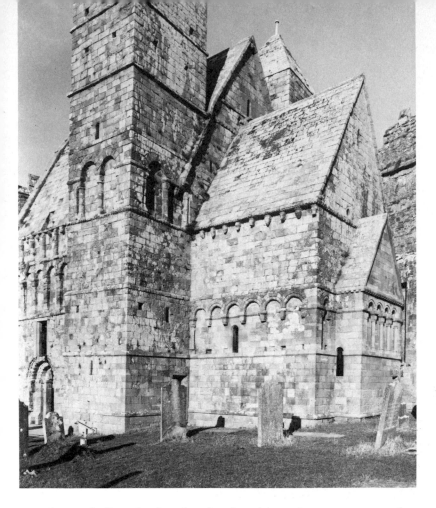

occasion underlines the fact that the church now becomes a somewhat neutral onlooker in the prolonged struggles and disputes between the local chiefs and their English conquerors. Already, in architecture, in sculpture, in manuscript illumination and in the later jewellery and metalwork, foreign influences have become widespread. With the Norman invasion reaching Ireland it is, where art is concerned, a question of more and deeper influences to be added to an already extensive list. The strong Celtic art, which earlier had absorbed with little trace such hints of Mediterranean art as reached the Irish shores, is much weaker in the eleventh and twelfth centuries, and continues to be changed and modified with the spread of Norman and English influences through the country. The continuity is provided by the

47

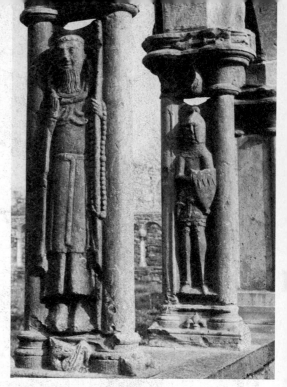

36 Jerpoint Abbey
(Co. Kilkenny), carved
monks in the cloister,
late twelfth century

church. And the Cistercian, Dominican and Franciscan Orders developed their styles of architecture along with all the other aspects of their mission in accordance with the changing society they served. The Cistercians continued to establish Houses up to the fifteenth century, when Holy Cross, in County Tipperary, was built. And the Franciscans followed the same path, building Quin Abbey in County Clare also in the fifteenth century. At that time, too, a cloister was *Ill. 36* added to the late twelfth-century Cistercian abbey of Jerpoint, in County Kilkenny, and decorated with standing figures which show the very considerable change in artistic direction in church sculpture.

The same development can be seen in metalwork. The Ballylong-
Ill. 37 ford Cross, which was made in 1479 for Cornelius O'Connor of Kerry, belongs to a tradition quite different from that which
Ills. 31, 32 produced the Cross of Cong. English and Continental influences can be seen in the treatment of the figure of Christ, in the foliate decorations around the edge, and in the replacement of detailed patterns by an extensive inscription on the arms of the cross. The base of the cross is joined to the shaft by means of a swelled, cushion-shaped boss surrounded by diamond-shaped knobs. The device is

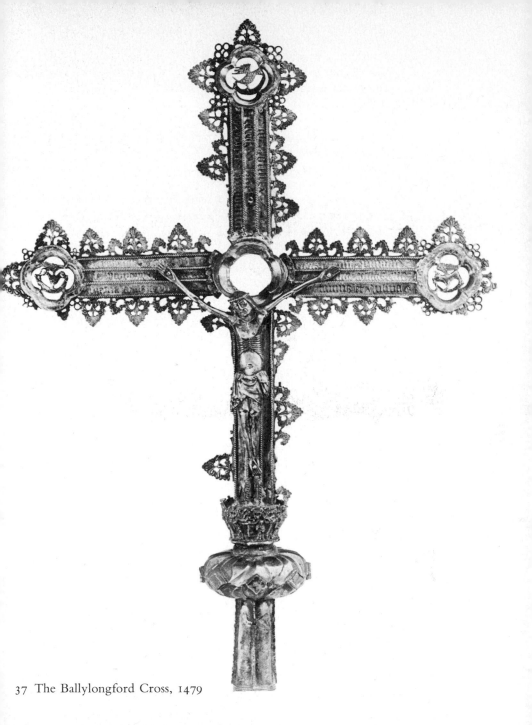

37 The Ballylongford Cross, 1479

almost identical to the swelling halfway up the stem of the De Burgo-O'Malley Chalice, and this would suggest a connection between the craftsmen responsible for the two works. The Chalice was made some fifteen years after the cross, in 1494, on the orders of Thomas de Burgo and Graunia ni Maile, and is in silver-gilt. In style it follows no native tradition. Similar chalices are to be found in Sweden, and five that are very close in style are at Aston-by-Sutton in Cheshire, Nettlecomb in Somerset, Coombe Keynes in Dorset, Corpus Christi College, Oxford, and the Royal Scottish Museum in Edinburgh.

This same alien nature can be detected in the carved figures of the fifteenth century, among the earliest carved wood sculpture known in Ireland. The carved figure of God the Father from Fethard is distinctly Spanish in style, although it was probably made in Ireland under foreign influence. The carved wood figure of the Clonfert Madonna, which is somewhat earlier, belongs also to a European convention, as does the other Fethard figure of Christ on Calvary and the carving of Saint Molua at Killaloe.

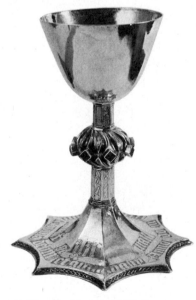

38 The De Burgo-O'Malley
Chalice, 1494

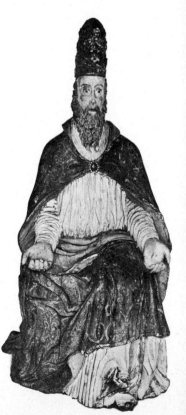

39 Carved figure of God the Father,
fifteenth century

Throughout the fifteenth century, English rule in Ireland continued to fluctuate according to the strength and ability of the King's Deputy. With the accession of Henry VIII new inroads were made which led to the assumption by the king of the title of Supreme Head on Earth of the Church in Ireland following the Reformation, and a death-blow was dealt to the great centres of Irish art, culture and learning with the dissolution of the abbeys and the confiscation of church property. Almost overnight the art and culture of the country were obliged to find new inspiration, new directions and new practitioners.

They came in two ways: from the urban craftsmen and their guilds, and from the patronage of the ruling classes. Both were directed and influenced from England, and later from the Continent, and both were opposed to what little native art or culture had survived the long periods of civil disturbance. But although alien in inspiration, this new direction in Irish art, the inevitable result of history, was to become as profoundly Irish in its way as any of the earlier influxes of ideas and styles. This was particularly true of the urban groups of craftsmen, the most important and influential of which was the Goldsmiths' Company of Dublin. But the first examples of what is best described as Plantation Art are of a very different sort from the domestic craft of the goldsmith.

In John Derrick's *Image of Irelande*, published in 1581, are recorded *Ill. 40* the campaigns of the Lord Deputy, Sir Henry Sidney, and the submission of 'the great O'Neale of Ireland' in 1578. The book contains a remarkable series of woodcuts of which several are signed with initials ID or FD. Possibly the ID refers to John Derrick himself. They are well drawn and vigorous representations of the events of Sir Henry Sidney's rule, the Irish chiefs against whom he was campaigning, his departure from Dublin, his army, drawn up and on the march, a pitched battle, and the capitulation of O'Neale and his followers – with which the book ends. The plates are fine examples of the artist's ability as a draughtsman, and are among the earliest visual records of Irish history and landscape.

The same military situation, though with different protagonists, gave rise to what may be described as the first example of Irish landscape painting, the large *Siege and Battle of Kinsale*, which is in Trinity College, Dublin. It is a military record of the various skirmishes and encounters in and about Kinsale during 1601–2, and in many respects, not least the bird's-eye view of events, it is more a

51

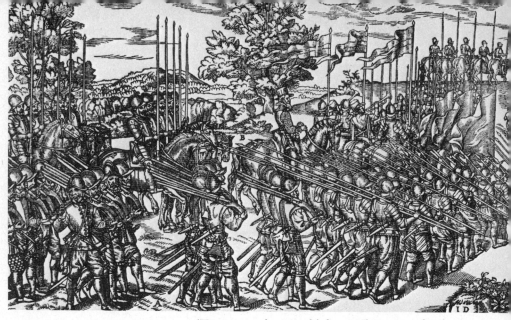

40 JOHN DERRICK 'Troops on the March' from *The Image of Irelande*, 1581

map than a landscape. Yet it is a picturesque panorama, with a fine sense of perspective, a lively treatment of the encounters between the English on the one hand, and the Irish and the Spanish on the other, with mounted and foot soldiers hurrying about in all directions in the foreground and with the general sense of bustle and activity well conveyed. The artist is unknown, although he is almost certainly the illustrator of Thomas Stafford's *Pacata Hibernia*, published in 1633, and the picture probably dates from that time.

The seventeenth century began with war and rebellion, reached a point of unequalled brutality with the Cromwellian campaign in the early 1650s, and drew to its close amid the Protestant rejoicing which followed the Battle of the Boyne in 1690. During this time the Dublin Goldsmiths' Company was established by Royal Charter from Charles I in 1637, and grew, at first under the influence of Dutch craftsmen working in Dublin, and later with the added impetus of Huguenot craftsmen who settled in Dublin at the end of the century, by which time the standards of craftsmanship were of a very high order. In Cork the goldsmiths formed part of a more general guild, or association of guilds, and the one-time master, Robert Goble, was the goldsmith who made the Mace of the Trade Guilds of the City of Cork, an excellent example of late seventeenth-century provincial

Irish work, in which the Dutch immigrant goldsmith, Charles Bekegle, is thought to have had a hand.

A silver tankard made by Edward Swann in Dublin in 1676 is a fine, plain example of the period, bearing the coat of arms of the Fletchers of Chester. Swann was a warden of the Dublin Goldsmiths' Company in 1660, having been made a freeman some six years earlier, and worked on in the city until the 1680s.

Considerable quantities of excellent plate were produced in Dublin during this period. There was an interruption during the Williamite wars, but by 1700, twenty thousand ounces of silver a year were being assayed in Dublin. Some of the best church plate belongs to this second half of the seventeenth century, and towards the end of the century there emerged among Dublin goldsmiths some craftsmen of rare distinction, among them Thomas Bolton, David King and Joseph Walker.

In painting this was almost exclusively the age of the portrait. Ireland did not have a rich or sufficiently settled society until well into the eighteenth century for the decorative art which flourished in England, and even the portrait painting of the period is largely the work of anonymous or forgotten artists. One figure, however, deserves special mention. Garrett Morphey (*fl.* 1680–1716), though

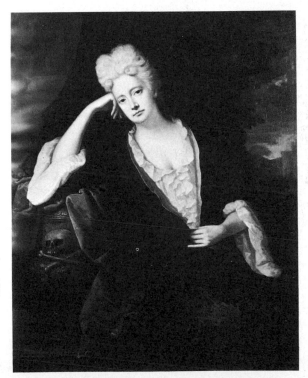

41 GARRETT MORPHEY
*Portrait of Frances Molyneux,
Lady O'Neil*

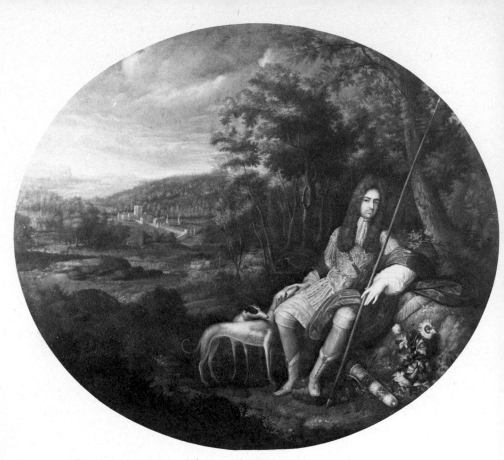

42 THOMAS BATE *Thomas, Lord Coningsby*

of obscure origins, was an active and prolific painter of portraits in Ireland during the last twenty years of the seventeenth century, though there are also records of commissions done by him for different families in England as well. He was a Roman Catholic painter, and originally known for his likenesses of the Irish martyr, the recently canonized Oliver Plunkett. His religious persuasion explains the fine examples of his work which are at Malahide Castle in north County Dublin, and record the connection between the Irish Jacobite family of Sir Neale O'Neil, a nephew of the Earl of Tyrconnel, and the Molyneux family. There are portraits of Sir Neale *Ill. 41* of Caryl, third Viscount Molyneux, and of Frances Molyneux, Lady

54

O'Neil. Morphey is a highly competent and sympathetic portrait painter, whose work has probably been more than decimated by wholesale re-attribution, a hazard found throughout Irish painting of the eighteenth and nineteenth centuries.

Thomas Bate (*fl.* 1690–1700) may well have suffered a similar fate, since remarkably little is known of his work or life. This may also be due, in part, to the fact that he painted on glass. His brilliant and detailed portrait of Lord Coningsby, acquired in 1975 for the Ulster Museum, became the museum's earliest Irish painting.

Towards the end of the century, probably at the instigation of the Duke of Ormonde, the English artist Francis Place (1647–1728) visited Ireland and did a number of important topographical drawings. His visit is important for what it tells us, particularly of Dublin, at that time. It is also interesting in being the first of many 'Irish Tours' undertaken by English artists, many of whom were to influence Irish painting and enrich it.

The last ten years of the seventeenth century were devoted to the stabilizing of Irish society, and the pattern which emerged by the early 1700s was to remain fairly constant during the next hundred years. Historically the picture, with its exclusively Protestant rule and its Penal Code, is not an attractive one. And it is, perhaps, fortunate that art reflects history only in a very oblique way. The Catholic population of Ireland was deprived, at this time, of the right to participate fully in the social life of the community, and art became a Protestant preserve. Perhaps the greatest irony of all lies in the fact that the Huguenots, themselves Protestant refugees from Catholic oppression, should have established themselves at the heart of many different areas of Irish creative activity at this time.

The age of Swift

Ill. 43 On the morning of 11 September 1710, Jonathan Swift sat for one of the many portraits painted of him during his lifetime by the Irish portrait painter, Charles Jervas. At ten o'clock that evening he wrote to Stella in his *Journal*: 'I sat four hours this morning to Jervis, who has given my picture quite another turn, and now approves it entirely: but we must have the approbation of the town. If I were rich enough, I would get a copy of it and bring it over.' A month later he was talking of getting a copy out of Jervas by surreptitious means, through the agency of a third party. And by 1716, when Jervas was in Dublin to paint yet another portrait, this time of Swift as Dean of Saint Patrick's Cathedral, Swift declared himself hard put to it to avoid the importunate artist. Whatever their relationship developed into, Charles Jervas managed to paint something in the region of a dozen different versions or copies of Swift's portrait, probably the best of them being the one in the National Portrait Gallery in London.

Ills. 43, 44 Charles Jervas (1675–1739) was the leading Irish artist of this period, and like so many painters who followed him, made his name as a painter in London. He was a pupil of Godfrey Kneller for about

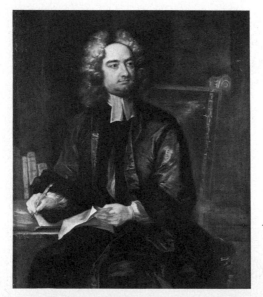

43 CHARLES JERVAS
Jonathan Swift

a year, although not highly regarded by the German artist who thought little of his ability as a draughtsman. He then went to Italy, and on his return married a rich widow with whom he set up house at Hampton. At that time even artists and writers were split by the political division into Whigs and Tories, and to some extent Jervas became the artist of the Tories, while Kneller was busy painting his kit-kat portraits of the Whigs. Jervas did several portraits of Pope, to whom he gave lessons in painting, and also portraits of Arbuthnot, Warburton, Thomas Parnell, Matthew Prior and Joseph Addison, besides a very large number of society portraits. In 1723 Jervas succeeded Kneller as principal painter to George I, and this post was confirmed on the accession of George II. During this period Jervas made at least three fairly extensive trips to Ireland, where he painted a number of portraits, including that of the Archbishop of Dublin, William King, now in the National Gallery of Ireland.

Jervas was a successful and fashionable painter in his own lifetime, but has since suffered from undeserved neglect. He was a vain man, with immense social aspirations, and his official position obliged him to paint large numbers of portraits of a formal and rather arid kind. Kneller was quite accurate though rather cruel in his condemnation of Jervas's abilities as a draughtsman, as can be seen in the proportions of his otherwise excellent painting of William Augustus, Duke of Cumberland, done in 1727, and now in the National Portrait Gallery. But Jervas painted flesh tones well, and was able to capture a likeness and invest it with life and vigour. A good example of the artist at his

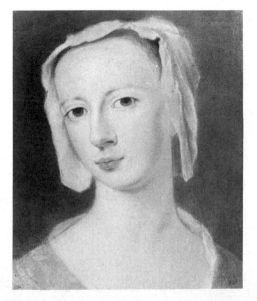

44 CHARLES JERVAS
Portrait Head of Catherine Hyde, Duchess of Queensbury

unaffected best may be seen in his *Portrait of a Girl*, with its direct simplicity, its fine flesh tones and straightforward composition.

Hugh Howard (1675–1737) was born in Dublin in the same year as Charles Jervas and studied painting in Holland and Italy before setting up in Dublin in 1700 as a portrait painter. He worked in the city for fifteen years, and then moved to London, where he married and settled. He was appointed Keeper of the State Papers, and gave up painting. He was a good artist, more flamboyant than Jervas, and a better draughtsman, but with a poor range of colour and a rather *Ill. 45* gritty texture to his work. His painting of Arcangelo Corelli, with its rococo framework of music and musical instruments, is a rather more entertaining picture than the portraits done of Dublin sitters, many of whom must have been clergymen and Fellows of Dublin University, such as Peter Browne, Provost from 1699 to 1710, whose portrait by Howard is in the Provost's House.

Though the work of Morphey at the end of the seventeenth century, and of Jervas and other artists in the early years of the eighteenth century, have special importance as the beginnings of what was to become an important strand in Irish art, it is not until the advent of James Latham (1696–1747) that we have an artist of major ability, and one who devoted all his energies to the pursuit of his art in Ireland. He was a portrait painter whose depth of perception, fully supported by great technical capacity, was to influence the development of Irish portraiture for many years to come.

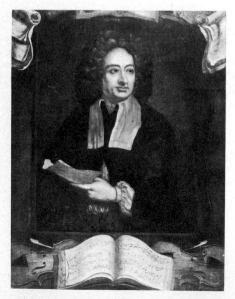

45 HUGH HOWARD
Arcangelo Corelli

46 JAMES LATHAM
George Berkeley

47 THOMAS FRYE
Portrait of an Artist

Because he worked almost exclusively in the comparative isolation of Ireland the documentation of any substantial body of his work is not available, nor does his reputation enjoy the position it should have in the eyes of collectors and scholars. He was born in Tipperary. He was for a time a student in Antwerp, and it appears fairly certain that he settled to a permanent job as a portrait painter in Dublin by the late 1720s. His best-known work is the portrait of George Berkeley, the *Ill. 46* philosopher and Bishop of Cloyne, owned by Dublin University. But in recent years many new works have come to light which reveal an artist of great talent, and a substantial influence on Irish painters of the mid-eighteenth century.

These include, in particular, Thomas Frye, Stephen Slaughter, John Lewis, Philip Hussey and Anthony Lee.

Thomas Frye (1710–62) was an artist of equal distinction, with rare qualities of draughtsmanship and composition in his pictures, although again few of his works are known, partly because his energies were side-tracked into the making of porcelain just at the height of his career and he spent fifteen years running a factory at Bow. Even then he did not return to the painting of portraits, but experimented with mezzotint processes, and published various prints up to his death from consumption in 1762. This was a pity. Frye's abilities as a portrait painter were considerable, as can be seen from his painting of Sir Thomas Wharton, and the fifteen years spent *Ill. 48* making porcelain, which brought him no profit and bad health,

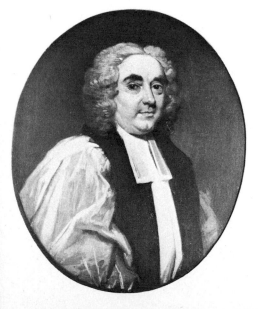

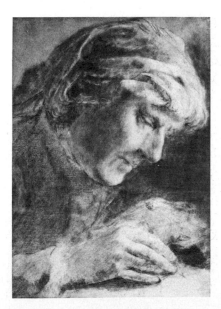

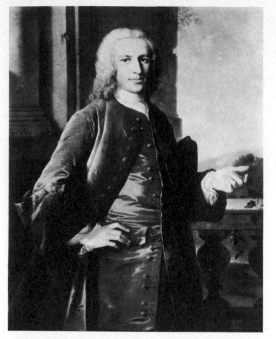

48 THOMAS FRYE
Sir Thomas Wharton

49 ANTHONY LEE
*Joseph Leeson,
First Earl of Milltown*

50 STEPHEN SLAUGHTER
*Portrait Group:
A Lady and Child*

interrupted a career of early achievement and great promise. Nevertheless, he developed an independence of style as an engraver, and the softness and depth of his technique in the making of mezzotints is justly recognized, and particularly admired in the two series of life-size portrait heads dating from the early 1760s. One of these is a self-portrait, and is close in style to the oil painting of Wharton.

Ill. 50 Stephen Slaughter (1697–1765) did the Irish circuit of principal towns and country seats over an extended period in the 1730s and 1740s, and was probably influenced in his style by Latham. There is a certain charm in his figures, even if it is slightly stiff, a mood of startled elegance, but the main direction of his powers as a painter seems to go into his florid treatment of draperies and decoration.

Ill. 49 Anthony Lee (*fl.* 1724–67) is known from a limited number of works dating from 1735 to 1745 which show the influence of Slaughter. Similarly, Philip Hussey (1713–83) seems to have admired Latham, but to have followed more closely after Slaughter, resulting in a certain superficiality of style. Hussey's career has many entertaining ingredients. He was five times shipwrecked, and it was said by Pasquin that 'his house, on every Sunday morning, was the

rendezvous of the literati and painters of Dublin, who there sat in judgement upon the relative occurrences of the week'. It was remarked, says Pasquin, 'that he was the most slovenly painter in Ireland, with the neatest apparatus'. What survives of his work would provoke a somewhat more generous final judgment. Lastly there is John Lewis, a scene painter at the Smock Alley Theatre, who is responsible for a small group of known portraits of considerable charm and simplicity. The best-known is the *Peg Woffington* in the National Gallery of Ireland.

Between 1730 and 1750 an important school of engravers was established in Dublin by John Brooks with the assistance of Andrew Miller. Brooks first learned engraving in Dublin, then went to work for Faber in London. There he met Miller, with whom he returned to his native city to set up a business publishing portraits and views. Brooks and Miller together are important in that they trained in Dublin some of the best eighteenth-century graphic artists in mezzotint, among them James McArdell (1728–65), Charles Spooner (d. 1767), Richard Purcell (d. 1766) and Richard Houston (1721–75), all of them born in Dublin, all pupils to begin with of Brooks, and all destined to achieve considerable reputations working in London in one of the richest but most difficult of graphic media.

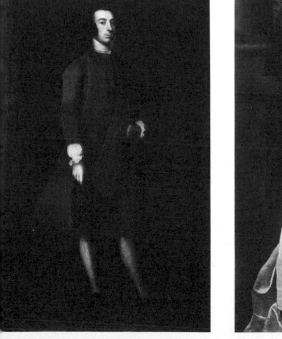 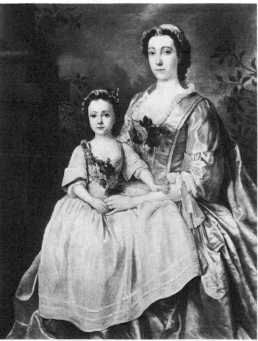

The artists who worked in Ireland in the first half of the eighteenth century were all, to some extent, pioneers. They had the traditions of London to fall back on, or to turn to, and there was quite close liaison between the two capitals. But in Dublin the stability achieved by the victory of William III at the Boyne was a very recent one, and its confirmation by the establishment of Irish *traditions* took time. The most important event in this connection was the foundation of the Dublin Society in 1731 for the purpose of 'improving husbandry, manufacture and the useful arts and sciences'. The Society was modelled on the Royal Society, and did itself become the Royal Dublin Society in 1820. Its first aims were scientific and agricultural, but by 1740 various schemes to aid artists had been started, including a small art school, run by Robert West (*d*. 1770) and the French artist James Mannin (*d*. 1779). This, combined with the premiums and awards given for art by the Society, and the purchases made from professional painters and sculptors in order to encourage them, created a vital and significant focus for the arts in Ireland. Most of the important sculptors and painters in Ireland during the eighteenth century were either trained by the Society's schools or benefited from its activities. And all artists could look upon the Society as a centre at which their work might be exhibited and sold, and from which commissions might be gained.

The start of an Irish landscape tradition cannot be precisely dated, but the influence of the Dublin Society was important, and it is significant that the first awards by the society were for landscape painting, first to Susanna Drury (*fl*. 1733–70) for her watercolour drawings of the Giant's Causeway in County Antrim, which were later engraved, and then, in 1741, to Joseph Tudor (*d*. 1759). Little else is known of Susanna Drury's work, though the Ulster Museum recently acquired two gouache drawings of the Giant's Causeway.

Engravings are often a valuable source of information about Irish landscapes at this time. Few of Joseph Tudor's paintings have survived, though the works we have reveal an artist of considerable ability; but he did complete an impressive series of six line engravings of Dublin, among the earliest views of the city. These were first published in 1745.

At roughly the same time the Tipperary artist, Anthony Chearnley (*fl*. 1740–85), was beginning to work in collaboration with the antiquary, Charles Smith, doing illustrations for his histories of Waterford and Cork. Again, his significance at the time is apparent

51 GABRIELLE RICCIARDELLI *Stillorgan Park and Obelisk*

from these, but so far too little of his work has come to light to demonstrate clearly his impact on landscape painting of the period.

More important figures of the mid-eighteenth century include Johann van der Hagen and Gabrielle Ricciardelli. Johann van der Hagen (*fl.* 1720–45) came from Holland, and worked in Ireland on a commission to paint the ports around the coast for a set of tapestries. His *View of the City of Waterford* is part of this scheme. He also painted theatre scenery for Smock Alley.

Gabrielle Ricciardelli (*fl.* 1748–77) did not arrive in Ireland until the 1740s, but was then a mature artist who immediately made progress, particularly as a painter of topographical views of houses and estates. Few of his works are definitely known, but those that are, and the many almost certain attributions, reveal an able artist, with a distinctive style and composition of his own, a fine understanding of perspective in landscape, a good draughtsman and a painter of very polished technique. A distinctive feature of his work is the generally low position of his horizon and the consequent emphasis he placed on the handling of his skies. The painting of Stillorgan Park and Obelisk, *Ill. 51* together with at least three other landscapes done around Dublin, are generally agreed to be the work of Ricciardelli. At the end of his life he went to London and exhibited landscapes there.

A number of other landscape painters were working in different parts of the country by the 1740s, many of them unknown primitives, like the painter of the mural at Mount Ievers in County Clare or the artist responsible for the view of Stradbally in County Leix. Both are *Ill. 52* close in style and composition to the two paintings of Westport *Ill. 53* House, signed and dated 'George Moore 1761', but almost nothing is

63

52 ANONYMOUS *View of Stradbally, County Leix*

known of this artist, and the accepted 'portrait map' style of all three pictures is not sufficient justification for attribution. The standard of Moore's painting is high, and his colour excellent.

One other important landscape artist of the period is John Butts (*d.* 1765), who was born in Cork and taught art by another landscape painter called Rogers. Both George Barret and James Barry were influenced by Butts, and Barry said of him, 'His example and works were my first guide and was what enamoured me with the art itself.' The importance of Butts, however, is largely a matter of hearsay. Only one certain Butts painting is known, with, in addition, one or two landscapes attributed to him. The discovery of further certain works would reveal a great deal, in view of his influence on other artists, about mid-eighteenth-century landscape painting in Ireland.

In spite of the limited number of pictures available to us generally, as well as the limited amount of information, the different manifestations in Irish art of the urge to depict scenery, often with more than just topographical intent, had left the country, by 1750, with a sufficient body of work to justify the interest and enthusiasm of Edmund Burke, who was to become a key figure – both as patron of artists and as theorist about the purpose and direction of art itself –

64

53 GEORGE MOORE *View of Westport House*

54 GEORGE BARRET *On the Dargle*

during the second half of the eighteenth century. This is dealt with more fully in the next chapter.

Goldsmiths flourished during the first half of the century and the best Irish silver of all belongs to this period. Men like Joseph Walker, David King, Anthony Stanley, Thomas Bolton, Thomas Sutton, Robert Calderwood and Thomas Williamson, to name only a few out of a host of excellent craftsmen, produced very fine work. Economic conditions and the time-lag in foreign influence kept much of the work within a simple and sometimes austere stylistic framework, but this tends to enhance the character of the best work, which, like the teapot made by John Clifton in Dublin in 1718, depends on line and shape rather than on decoration. Some excellent work was also produced in Cork, and goldsmiths were establishing themselves in other provincial centres such as Galway and Kinsale. Only after 1730 does Irish silver begin to assume definite and increasing characteristics of its own, with rich if flat-chased rococo decorations, and the full variety and range of this era belong more to the second half of the century.

Many of the styles and decorative techniques which are so well documented in silver appear also in Irish furniture, plasterwork, and the rare examples of Dublin and provincial delftware which have survived. Much of the work reflected the growing prosperity and independence of the country, and it is not surprising that Italian, Dutch and German influence and inspiration should be felt, as well as *Ill. 55* English stylistic undertones. The Italian stuccoists, Paul and Philip Francini, were probably responsible, directly or through their pupils and followers, for the greater part of all Irish plasterwork. In furniture the names of few cabinet-makers have survived, although stylistic idiosyncrasies have established a definite and fairly rich tradition,

55 FRANCINI BROTHERS
Marcus Curtius

much of it provincial in manifestation. Delftware of a high quality was made in Dublin, Belfast, Limerick and Rostrevor during the middle of the eighteenth century, and in Dublin some really fine ware was produced during the 1750s by Captain Henry Delamain, who was helped by both the Dublin Society and the Irish Parliament. Much of his work is decorated in blue or manganese-purple, and the motifs are often of Chinese origin, although many dishes had landscapes painted on them.

Our information on the art of the first half of the eighteenth century in Ireland is limited, often severely. Many of the most influential artists are known only by a handful of paintings, much of the work is unidentified, there are numerous doubtful and highly speculative attributions, and there are probably many paintings by Irish artists of this period, among them their best works, which are at present masquerading in various collections as the creations of far more illustrious names. Even so, by the 1750s, definite characteristics and trends had become apparent in the arts in Ireland, and there was, through the activities of the Dublin Society, a corporate feeling and a sense of national self-confidence and pride which was to come to an abundant fruition during the second half of the century.

Ireland her own

At a meeting of 'The Club', possibly in Trinity College, in May 1747, Edmund Burke, at that time about nineteen years old, was 'order'd to make a Declamation in praise of painting'. His remarks are summarized in the minute book of 'The Club', which later became the College Historical Society. Burke said:

> That there are three arts, called generally by way of eminence, polite poetry, painting, & musick, that painting is in many things not inferior to poetry, and doubtless superior to Musick, that it gives us all the beauties of nature with the additional pleasure that the mind takes in comparing them & finding their resemblance wth the original, that it greatly tends to the furtherance & improvement of virtue by putting before our eyes the most lively example of the reward of it or the punishment of the contrary. Like St Paul preaching at Athens (a piece of Raphael) it convinces some, astonishes and pleases all. Portraiture particularly useful by showing our Ancestors who have done well, we may be incited to follow their example for wch ends the Romans kept the statues of their ancestors in their houses.

For his remarks Burke 'had the approbation' of the small debating society. Out of those remarks came one of the more influential works on aesthetics of the eighteenth century, *A Philosophical Enquiry into the Origin of our Ideas of the Sublime and Beautiful*. Although the work was not published until 1756, it is generally accepted that it was written a good deal earlier, and in a letter written three nights after the meeting of 'The Club', Burke refers to what could have been the first draft of the work, which he later claimed to have started in his eighteenth year. The essay is unjustly neglected, mainly on account of its basic thesis – a Beethoven–Schubert syndrome for the visual arts – which splits creative works into those which excite ideas of pain or danger, and are therefore sublime, and those which induce love, and are therefore beautiful. But whatever the argument may be about it today, in its own period it was an influential work, admired by

Lessing and Kant, and containing within it many of the seeds of Romanticism. It is also of considerable importance in Irish art. Burke was not just a philosopher. He was deeply interested in painting and in painters, and remained so through his life, and he was the patron, friend, and probably the aesthetic guide and teacher, of the two most important Irish artists of the second half of the eighteenth century, George Barret (1732–84) and James Barry (1741–1806). Both artists reflect the philosophical ideas contained in *The Sublime and Beautiful* in much if not all of their work, and it could be said of James Barry that a great many of his pictures epitomize Burke's idea of the sublime, particularly a painting like *King Lear Weeping over the Dead Body of Cordelia.*

Ills. 57, 58

Ill. 58

George Barret was the son of a draper, and apprenticed in his youth to a stay-maker. He studied art under Robert West, and won a prize from the Dublin Society at one of the annual exhibitions. For some time he taught drawing, and also coloured prints, and it was probably while Barret was still in his late teens that he met Edmund Burke, four years his senior, who encouraged him to put some of the elder man's philosophical opinions to practical application. Barret did so. For nearly ten years he painted landscapes in the counties of Dublin and Wicklow. They include among them some of the earliest examples in the British Isles of 'wild scenery' for its own dramatic sake. In 1762 Barret went to London. He exhibited there a number of his Irish landscapes, and their originality, which derived from first-hand experimentation based on a theory of painting rather than on example, won him a reputation in a fairly short space of time. There are a number of somewhat apocryphal stories about the large sums of money Barret earned from his painting, but it is certain that he was enormously popular. He became bankrupt, however, and was rescued towards the end of his life by Edmund Burke, who secured for him the lucrative sinecure of Master Painter to the Chelsea Hospital. Barret was a founder-member of the Royal Academy.

Ills. 54, 56

His painting has been unduly neglected, as it was unduly praised in his lifetime, and he is generally dismissed as a rather poor follower of Richard Wilson. Wilson probably influenced Barret, but not really to Barret's advantage as a painter. Indeed the Irishman's art divides quite clearly into two periods – before and after the encounter with the English tradition of classical training and ideals. When Barret arrived in London he was an artist of considerable originality. The only landscape he had experienced was the richly picturesque and varied

56 GEORGE BARRET *Powerscourt Waterfall*

Ills. 54, 56

one of the countryside south of Dublin, and possibly Killarney. This included such venerated tourist spots of the eighteenth century as the Dargle, Powerscourt Waterfall and the mountains and valleys of Wicklow and Dublin. He painted them as he found them, with rich masses of trees and wild waterfalls, little attempt to conventionalize the composition by the introduction of foreground 'framework', and a rapid style and thick impasto which sometimes produced a certain crudity while at the same time giving to his work great vigour and strength. Even in his earliest pictures his treatment of trees was very accomplished, and his sense of light highly effective and unusual. He often painted *into* the light, with dramatic, silhouette effect, and time and again with these early works one is aware of a strikingly original hand and eye, with little more than rudimentary training, being applied to landscape, and achieving a distinctive and powerful interpretation which at different times must have satisfied both of Burke's theoretical requirements.

The later, London, phase in Barret's work should be further subdivided. At his worst, success made him the dull and conventional painter of technically quite skilful canvases which are smooth and

harmonious, but often lifeless. They betray most of the signs of a superficially felt conviction, with their careful framing of the middle ground and distance by foreground foliage, trees to left and right, and the traditional figure of shepherd or cowherd in the corner, with his dog and his beasts. And the light itself in these works, a golden, classical suffusion over everything, while technically law-abiding, lacks the fine sharpness and character to be found in his early works.

But this is true of only a proportion of his mature output. He also painted excellent landscapes which combine his former originality with the kind of mastery which only experience gives. Typical of these would be the series of views he did for Norbury Park.

Barret probably lacked the sort of self-confidence needed to preserve his artistic character and independence in the highly competitive environment of London in the 1760s. His early success and the frequent commissions which followed it demanded a fluent and fairly rapid style which could be easily varied and repeated, and adapted where necessary to the kind of views which his clients asked for. From Wilson's carefully developed classicism Barret appears to have taken the rudiments only, and there is an uncertainty in his later work which is regrettable. The fault is one to which many Irish artists have succumbed in their graduation from Ireland to London, if indeed it can always be called a fault. The irony is that Barret is almost always judged on his late, mature work, and at times found wanting, while his early paintings, with their originality of style, composition and light, are generally ignored. And this basic dichotomy is further complicated by the fact that Barret was too good an artist not to be continually improving and refining his technical ability; where he found in himself a lack, as with figures and animals, he was not above calling in the help of various other artists, including Sawrey Gilpin, George Stubbs and Philip Reinagle, the latter two of whom were responsible for the figures and animals in *A View Looking East towards Knipe Scar from Lowther Park*.

James Barry was a very different kind of artist. He was a Catholic, *Ills. 57, 58* the son of a bricklayer, and was born in a small cottage in Cork. He went to sea at an early age, but soon gave it up and devoted his time to art. He was influenced by the Cork landscape artist, John Butts, and at the age of twenty-two, in 1763, he went to Dublin, where he was awarded a prize by the Dublin Society for his *Saint Patrick Baptising the King of Cashel*. He came to the attention of Edmund Burke, and in the following year went to London with him and was introduced to

Reynolds and other leading English artists of the time. At this stage Burke was a good deal more influential than when he had met Barret in the early 1750s, and it is not unreasonable to imagine that his effect on Barry was a good deal more profound and long-lasting. At the same time it was probably as bad for Barry as it was good for Barret. Burke was a man who believed in the superiority of the emotions over the intellect, and this belief is at the root of his aesthetics. In leading Barry towards an attempt on the sublime in art – and Burke is at least partially responsible for this – he was placing the Cork artist on a line of development for which he was technically ill-equipped; and from his arrival back in England in 1771, after working and studying art in Rome for five years, until his death in 1806, Barry's powers of visual composition, his draughtsmanship, his handling of paint, even so elementary a thing as his understanding of human anatomy, could not match the range of his imagination and vision. There is an element of strain and tension in many of his paintings which results from this, and which reaches a level of overstatement in, for example, some of the large wall paintings done for the Royal Society of Arts *Ill. 57* from 1777 to 1783. Barry's *Adam and Eve* avoids the more obvious pitfalls, but even so is limited by more mundane considerations.

57 JAMES BARRY
Adam and Eve

58 JAMES BARRY
*King Lear Weeping
over the Dead Body
of Cordelia*

Redgrave says that it 'evinces no feeling for colour, and even the forms are inelegant, unduly round, and without interior markings, their pose somewhat stiff, and the action not easy'. It was exhibited in London in 1771, and the following year Barry became an Associate of the Royal Academy, gaining full membership in 1773.

As well as working on the wall paintings for the Royal Society of Arts, Barry painted several portraits, including at least one of Edmund Burke, and a number of self-portraits which reveal much about his character. His tongue and his temper made him many enemies, lost him the RA Professorship of Painting and eventually brought about his expulsion.

The ambivalence of Barry's character as an artist can be seen more clearly in *King Lear Weeping over the Dead Body of Cordelia*. The Ill. 58 strange mixture of his romanticism, derived from the influence of Edmund Burke's treatise, and a classicism which relates strongly if unevenly to the rising star of French classicism under David, reaches an uncertain apotheosis in this remarkable work. It bears some relationship to the direction in which William Blake's art was moving at the same time, but whereas Blake was forging an entirely English creative technique and vision, Barry was falling victim to the

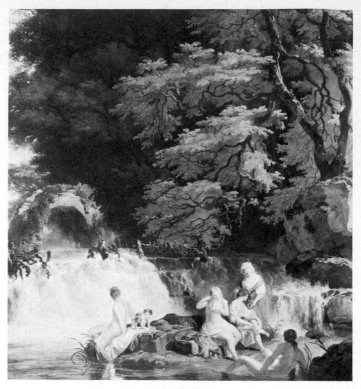

59 FRANCIS WHEATLEY *Nymphs Bathing, a View of the Salmon Leap at Leixlip*

60 FRANCIS WHEATLEY *View of College Green, with a Meeting of the Volunteers, on 4th November, 1779*

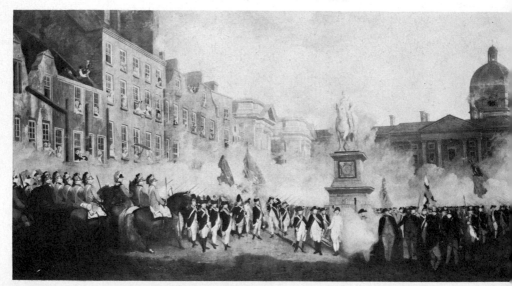

rootlessness which must have been, in part, a result of his uneasy and unhappy sojourn in London. The Lear painting, as well as other canvases worked on a grand design, may perhaps be judged a failure; but if so, it is a noble one.

Francis Wheatley (1747–1801) was a London artist and a pupil of *Ills. 59, 60* Richard Wilson's. He made his first visit to Ireland before he was twenty, and did some landscapes which were then shown in London. In 1779 Wheatley returned to Dublin, this time to avoid his London creditors, and stayed in Ireland until 1784, a period marked by some of his most important paintings, and a period during which his probable influence on Irish topographical artists like Malton and Fisher was considerable. Wheatley is at his most delightful in rustic or arcadian landscapes, whether in watercolour or oil. His *Nymphs* *Ill. 59* *Bathing, a View of the Salmon Leap at Leixlip* is a perfect example of his smooth and relaxed technique, his excellent colours and clever composition. He painted water, foliage and human figures with great proficiency, and numerous watercolours of great beauty indicate the range of his ability in this medium. He was also a portrait painter of distinction. Some of his portraits seem rather stilted because of the attempt to combine them with landscapes, as in the *Review of Troops in Phoenix Park, 1781* and the portrait of Admiral Arthur Phillip, both in the National Portrait Gallery. In the same Gallery are a spirited self-portrait, and a painting of the elderly Henry Grattan.

But Wheatley's most significant work was the historical painting done in Ireland, including his *View of College Green, with a Meeting of* *Ill. 60* *the Volunteers, on 4th November, 1779* and his painting of *The Irish House of Commons, 1780*. Wheatley handles these large subjects with the same ease and balance that he applied to much smaller works. He gives as much vigour and reality as possible to what is basically a collection of cameo portraits and a journalistic record of an 'event', and he paints it with his usual skill and harmony. Side by side with this quite natural and commercially inevitable movement of artists between London and Dublin, a truly indigenous and rich Irish landscape style was being developed by a group of painters in Ireland of whom the leading figures were George Mullins, Thomas Roberts, his brother Thomas Sautelle Roberts, Nathaniel Grogan and William Ashford.

George Mullins (*fl.* 1763–75) was a landscape painter in the classical *Ill. 61* style, who worked for the Earl of Charlemont as well as being a regular exhibitor in the early 1770s at the Royal Academy. His

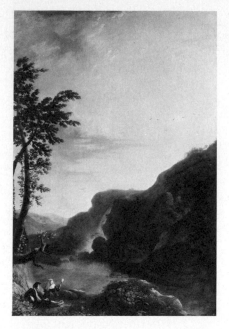

61 GEORGE MULLINS
Landscape

62 WILLIAM ASHFORD
*The Casino at Marino,
near Dublin*

canvases are often big, and his treatment open and vigorous. He taught the elder Roberts brother.

Ill. 62 Thomas Roberts (1749–78) shows in his style a promise that would almost certainly have put his reputation above that of William Ashford had he lived beyond his thirtieth year. His canvases have a limpid, cool completeness about them, a feeling of calm and natural peace and order. There is a polish in his composition and a balance in his colour which is rarely to be faulted; yet his work is never lifeless, it vibrates with sun and light. He was patronized by the Duke of Leinster and Lord Powerscourt, which explains the number of works by him which were 'portraits' of houses or estates. Yet in these, as in his more natural landscapes, he achieves a sense of roundness and fulfilment which is entirely pleasing.

His brother, Thomas Sautelle Roberts (*c.* 1760–1826), was much younger, and evinces very different stylistic trends in his work. He was subject to the emotional forces of Romanticism, and his landscapes in the early years of the nineteenth century display that love for the dramatic that was to become an important thread in Irish, as in English, painting through the century. His best work is of wild and natural subjects, of water, rocks, trees and stormy skies. He often distorts his scale in order to add drama to the view he is painting. He

76

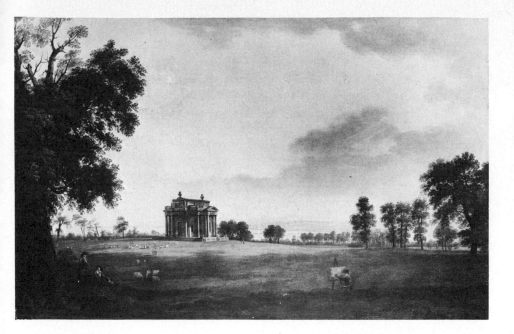

was responsible for a number of more formal, practical works of topography in Dublin and Wicklow, as well as other parts of the country, and most of these were engraved. They are misleading as far as his style as a painter in oils is concerned. He was a founder member of the Royal Hibernian Academy.

Nathaniel Grogan (*c*. 1740–1807) is the only artist in this group not of Dublin, and while he painted several fine landscapes, his tastes as a painter were more diverse, leading him into character studies and humorous works as well as some portraiture.

William Ashford (1746–1824) fully earns his position as the central figure among landscape painters in Ireland during the period. He was born in Birmingham, and settled in Dublin at the age of eighteen. From 1767 until 1821 he exhibited regularly in Ireland, and lived on to see the Royal Hibernian Academy established with himself elected as its first president in 1823. *Ill. 62*

During the long span of his working life, mainly as a landscape artist, Ashford's style developed steadily and evenly. By the late 1790s and early 1800s he was painting superb large canvases in which the even balance of good light and fine composition gave him mastery, whether his subject was a specific view – often of a country seat or beauty spot – or an imaginative composition. Large canvases also

77

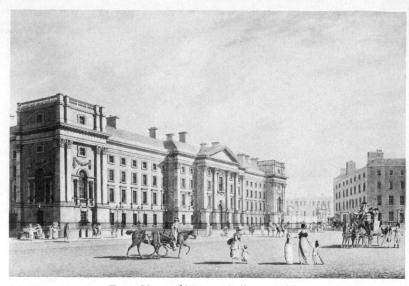

63 JAMES MALTON *Front View of Trinity College, Dublin*

suited his style, which was open and expansive. He worked for Lord
Fitzwilliam in the early 1800s, and paintings from this period belong
to the Fitzwilliam Museum in Cambridge. His painting of the
Marino Casino was also completed at about this time.

James Malton (*d.* 1803) started his working life in Ireland as a
draughtsman in the office of the architect, James Gandon, during the
time of the building of the Custom House, for which work Gandon
came to Ireland in 1781.

Ill. 63 But Malton's greatest work was his collection of Views of Dublin
which were drawn in 1790–1, and published in parts during the
following eight years. They are the finest views of Dublin ever done,
and they rank with the best topographical views in Ireland or
England at that period. The twenty-five views were engraved in
etching and aquatint. Malton issued two trial views in 1790, one of the
Custom House and one of the Parliament House, in the latter of
which two pigs were drawn, but later removed in the published plate
of 1793. It is generally believed that objections were raised to the pigs
by members of the Irish Parliament. Regular publication began in
Dublin and London in 1792. The plates were worked from
watercolour drawings by Malton himself, and were printed in sepia
and in black. Coloured sets were issued, the hand-colouring generally
done on sepia plates, and they were so popular that printing of the

views continued up to the 1820s, by which time the plates had become extremely worn. As well as the original watercolours Malton did watercolour copies, and he also coloured in outline etchings, probably as guides to the colourists he employed. The views are principally architectural in style, although he did capture much of the atmosphere of the city at that time. In the early 1790s, after taking the views but before their publication, Malton left Dublin for London where he spent the rest of his life. He committed suicide in 1803.

Jonathan Fisher (*d.* 1809) was, like Barret, the son of a draper, and a self-taught artist. He was a painter of topographical landscapes, and spent most of his life painting views in Ireland which were then engraved, the early ones by engravers employed by Fisher working in line, the later series of sixty plates in his *Scenery of Ireland* aquatinted by the artist himself, and published in 1796. Fisher's painting of the Lower Lake, Killarney, was later engraved, as were almost all his *Ill. 64* works in oil.

While Malton and Fisher worked largely on their own, there were several collections of views in Ireland which brought together many of the landscape artists. Thomas Milton (1743–1827) engaged a number of them to do watercolour drawings for his *Views of Seats in Ireland* and Francis Grose (1731–91) employed several Irish artists to work on his *Antiquities of Ireland* in the 1790s.

64 JONATHAN FISHER *View of the Lower Lake, Killarney*

Many portrait painters were working in Ireland during the second half of the eighteenth century. Nathaniel Hone (1718–84) was an enamelist and portrait painter in oils. At his straightforward best he was an excellent artist. His portrait of John Camillus, his youngest surviving son, is a delightful piece of work. Called *The Piping Boy*, it is inspired by affection and sympathy, and is painted with simplicity and directness. The portrait of John Wesley in the National Portrait Gallery is another fine painting, and so is the portrait there of 'Kitty' Fisher, the unfinished half-length of Horace Walpole and the self-portrait. He painted a number of these, perhaps the best of which is the one in London, although there is a good self-portrait in the Manchester City Art Gallery. They all reveal a rather proud and aggressive man, and not without justification. Hone engaged in a number of rows, one of which resulted in *The Conjuror*, in which he ridiculed Angelica Kauffmann, and which was thrown out of the Royal Academy exhibition. It is now in the National Gallery of Ireland. Hone also painted a number of miniatures. Both of his sons, Horace and John Camillus, were artists, as well as his brother, Samuel, with whom he had a close physical resemblance.

Horace Hone (1756–1825) was unquestionably the finest Irish miniature-painter, and by any standards a miniaturist of great talent.

Ill. 66

Ill. 65

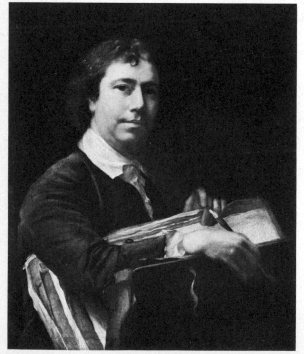

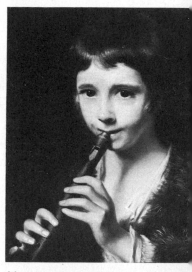

65 NATHANIEL HONE
Self-portrait

66 NATHANIEL HONE
The Piping Boy

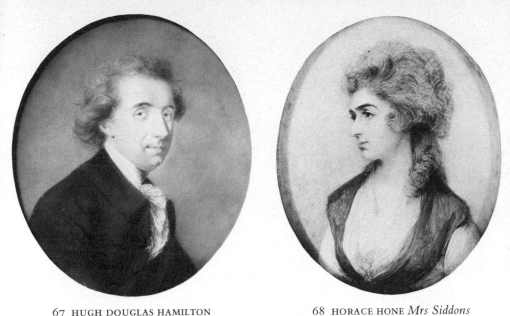

67 HUGH DOUGLAS HAMILTON
Walter Hussey Burgh

68 HORACE HONE *Mrs Siddons*

He learnt from his father, and exhibited his work in London before
setting up in Dublin in 1782. In the following year Mrs Siddons made
her first appearance at the Smock Alley Theatre, and in 1784 Hone
did his fine portrait of her, with its poignant expression and softness in *Ill. 68*
the features, conveyed with an extreme delicacy of touch. His self-
portrait, in the National Gallery of Ireland, is an accomplished
miniature, and so is his portrait of Charles, Duke of Rutland, Lord
Lieutenant of Ireland. Hone was a prolific artist, both during the
period in Dublin, and later, after his return to London where he
continued working for a further twenty years.

Hugh Douglas Hamilton (1739–1808) devised his own style of
portraiture in pastel, became very skilful at it, and enjoyed a long and
successful career doing portraits which are halfway between
miniatures and full canvas paintings. They are finely drawn in black,
white and coloured chalks, usually about ten by eight inches, good
likenesses, with expressive and lively appearances, good handling of
eyes, hair and flesh, and a kind of restrained freshness in them which is
most attractive. He worked for six years in Dublin, and then went to
London, where he was equally successful. His portrait drawings vary
little, yet they never seem to lose the charm and spontaneity of a good
likeness taken at one sitting. His portrait of Walter Hussey Burgh is a *Ill. 67*

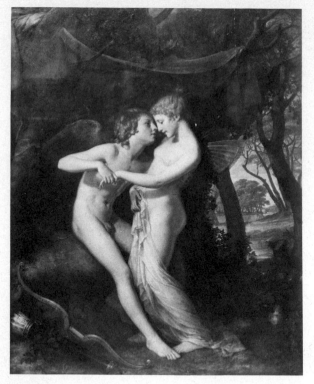

good example of his work. In 1778 he went to Italy and settled in Rome where he stayed for twelve years. He came under the not too happy influence of Flaxman, who persuaded him to attempt more ambitious subjects. This resulted in work like his *Cupid and Psyche in the Nuptial Bower*, although this was probably completed after his return to Dublin in 1791, where he continued his practice, doing many more portraits in oils, until his death in 1808. These last works are very fine and include leading Irishmen of the period, John Philpot Curran, Lord Edward FitzGerald, Viscount Kilwarden and a fine head of the Irish banker, David La Touche, a man he had drawn in chalk twenty or so years earlier. All these works are in the National Gallery of Ireland which has the best collection of Hamiltons in existence.

Ill. 69

A number of other portrait painters and miniaturists worked during this period. Thomas Hickey (1741–1824) began like Hamilton working in chalk, and produced a very early and competent portrait of Charles Lucas, in black and white crayon on grey paper, which is in

82

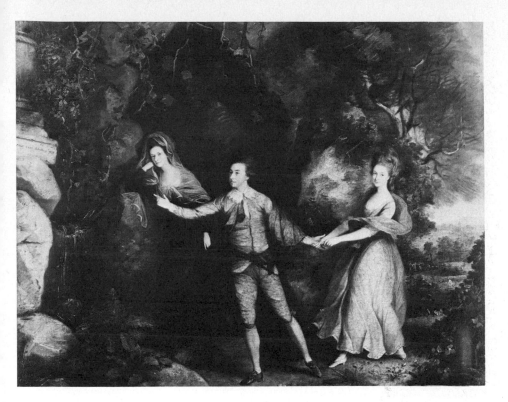

the National Gallery of Ireland. He then progressed to portraits in oils, often of groups, and to theatrical paintings, including his *An Actor between the Muses of Comedy and Tragedy*. It is a rather stilted picture and over-dramatized, a fault which his portraits also suffer from. He later visited India and China, and the pictures he did there have a certain distinction and charm, although they remain a bit lifeless.

Ill. 70

Francis Robert West (1749–1809) was the son of the first master of the Dublin Society's school, and was taught by his father. He also worked in pastel, and there are some pleasing portrait drawings in the National Gallery of Ireland, but not of any great distinction. One of his pupils was Robert Healy (*fl.* 1760–71), an artist who worked principally in black and white chalk on paper. His portraits, and studies of horses and figures, are soft and subtle in texture and composition. Another of West's pupils was Matthew William Peters (1741–1814) whose career, spread between Dublin, London and the Continent, as well as his predilection for painting langorous and

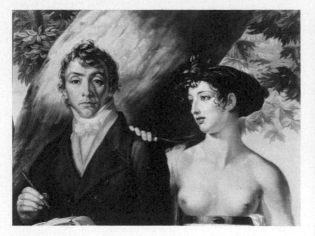

71 ROBERT FAGAN
Self-portrait of the Artist and His Wife

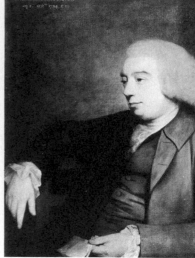

72 ROBERT HUNTER
Francis Hutcheson

mildly erotic female figures, have obscured his qualities as a colourist
of considerable ability. Robert Fagan (1767–1816), who was deaf, was
a Cork artist who lived in Rome and Naples, and painted a number of
portraits there. His figures are strongly drawn, in the neo-classical
style. In 1780 Robert Home (1767–1834) arrived in Dublin, and for
ten years flourished in the city as a portrait painter. He was
commissioned by Trinity College to paint a series of full-length
portraits, including Burke, Swift, Berkeley, King and Ussher. The
only one done from life was the portrait of Henry Grattan, and this
seems to have disappeared. Home's arrival in the city deprived Robert
Hunter (*fl.* 1752–1803) of work. Hunter, who came from the north of
Ireland, was in many ways a more honest and sympathetic painter.
His large, full-length portrait of Nicholas, Lord Taaffe, is an excellent
piece of work, and his portrait of the Irish composer, Francis
Hutcheson, is well painted. It was at first thought to be a portrait of
the composer's father, the philosopher of the same name. There were
two other painters in the north of the country at this time, Joseph
Wilson (*fl.* 1770–1800) and Thomas Robinson (*d.* 1810). Robinson
actively associated himself and his art with the early development of
Belfast, and his most important painting, *The Entry of Lord Hardwick
into Belfast as Lord Lieutenant, 27th August 1804*, was done there the year

Ill. 71

Ill. 72

Ill. 73

84

before Trafalgar. Wilson worked in Belfast and in Dublin, and a number of his portraits are in the Ulster Museum.

The development of sculpture in Ireland during the second half of the eighteenth century was primarily a result of the work of John Van Nost and Simon Vierpyl, and the financial encouragement of the Dublin Society, John Van Nost (*d.* 1787) came to Dublin in about 1750 from London where his father was a sculptor of some note. He had a virtual monopoly in the city, and completed several important works, including the equestrian statue of King George II shown in Malton's view of St Stephen's Green, as well as numerous portrait busts. Simon Vierpyl (1725–1810) came under the patronage of Lord Charlemont but confined his work mostly to stone carving and did little statuary. He was employed on the decoration of the Marino Casino shown in William Ashford's landscape, and did a few portrait busts which are in Trinity College. Patrick Cunningham (*d.* 1774) was the first Irish sculptor of note. He was apprenticed to Van Nost by the Dublin Society and did some portrait work, including a bust of William Maple, but he spent much of his time doing wax modelling, which sold better, and the greater part of his output is now lost. But Simon Vierpyl had in his apprentice, Edward Smyth (1749–1812), a

Ill. 74

Ill. 62

Ill. 75

73 THOMAS ROBINSON *The Entry of Lord Hardwick into Belfast as Lord Lieutenant, 27th August 1804*

far more versatile and significant artist. Smyth, son of a stone-cutter, was employed in the same capacity by Darley, an employee in turn of Gandon's, the architect of the Custom House. Gandon was greatly impressed by Smyth's work, and employed him, not only for the sculptures on the Custom House, but on all his Dublin building. Much of his work has weathered, but the fine set of heads representing the rivers of Ireland which decorate the Custom House indicate an artist of considerable vigour and originality. Two other sculptors of note belong to this period, John Hickey (1751–95) and Christopher Hewetson (1739–99). Much of Hickey's work was in the form of monuments in churches, the finest of which are in St Peter's Church, Drogheda, to Henry Singleton; in Delgany Church, to David La Touche; and in St Helen's Church, Abingdon, to Mrs Hawkins. Hewetson's best work is the Baldwin Monument in the Theatre at Trinity College. He did some portrait busts, including one of the Duke of Gloucester in 1772, at Windsor.

The second half of the eighteenth century was one of the most prosperous and exciting periods in Ireland, and it was fortunate that the prosperity, together with the growth and expansion of Dublin which resulted from it, should have come at a time when taste and

Ill. 77

Ill. 76

74 JOHN VAN NOST *Thomas Prior* 75 PATRICK CUNNINGHAM *William Maple*

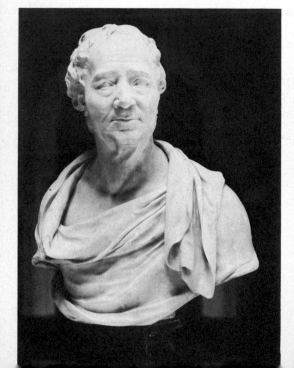
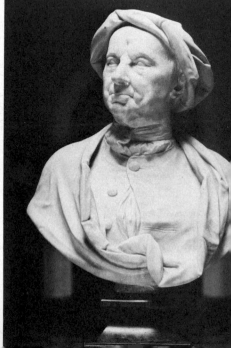

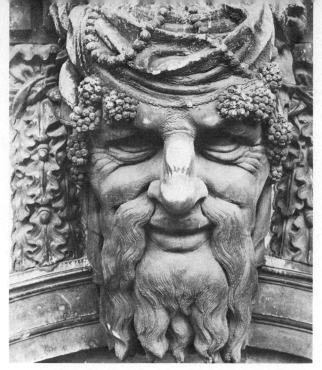

76 EDWARD SMYTH
Carved head representing
the River Bann

style in all things, but particularly in architecture, were capable of producing a whole range of buildings, both public and private, which were not only fine and impressive, but memorable, and on occasion inspired.

While architecture deserves a history of its own, it is essential to sketch in briefly the most important figures, going back to the early eighteenth century. The first name of importance is that of Sir Edward Lovat Pearse (*c.* 1699–1733), a cousin of Sir John Vanbrugh. He designed the Parliament House in Dublin, now the Bank of Ireland, and many important private houses.

An assistant to Pearse in the building of the Parliament House was Richard Castle (*c.* 1690–1751), who effectively took over Pearse's practice after 1733, and became the architect of numerous country houses, including Hazlewood in Sligo, Westport in Mayo, Carton in Kildare, and Russborough and Powerscourt, both in Wicklow. He was also responsible for Leinster House, the present Irish Parliament building.

The chief architect of the second half of the eighteenth century as well as being the greatest architect to have worked in Ireland was James Gandon (1743–1824), responsible for two great Dublin *Ills. 77, 78*

77 JAMES GANDON The Custom House, Dublin

buildings, the Custom House and the Four Courts, as well as other work. Gandon was born in London, and studied under Sir William Chambers. He did a number of quite important works in London *Ill. 77* before being invited to Ireland to build a new Custom House in 1781. The work took him ten years, cost £300,000 and was attended by various difficulties over labour, material and vested opposition to moving the main centre of commerce down river by half a mile from the site of the previous custom house. But the building, when finished, became one of the chief glories of the city, and is still among the finest examples of eighteenth-century architecture in the British Isles.

Ill. 78 Gandon went on to design the Four Courts, another splendid example of Irish architecture during this period, the King's Inns in

78 JAMES GANDON The Four Courts
from the Merchant's Quay, Dublin

Henrietta Street, Carlisle (now O'Connell) Bridge and the alterations to the Parliament House carried out in 1785.

Of Irish-born architects, Thomas Ivory, Francis Johnston and Richard Morrison should be mentioned. Thomas Ivory (*c.* 1720–86) was the master of architectural drawing in the Dublin Society schools between 1759 and 1786. He came from Cork, but little is known of his life, and few of his buildings are recorded. His finest work is the Blue Coat School on the north side of the River Liffey. Francis Johnston (1761–1829) belongs to a slightly later period. He had a distinctive style, and among other things was responsible for a series of Irish Georgian castles, some of them original, others additions to existing buildings. Johnston was a busy and successful architect, and much of his work belongs to the nineteenth century, not only in date but to a great extent in style as well, for he was an innovator of considerable originality. He designed the General Post Office in Dublin, burnt but not demolished in 1916, and also the Nelson monument which was blown up in 1966. One of his finest and most distinctive achievements is St George's Church.

79 JOHN ENSOR Merrion Square, Dublin

Sir Richard Morrison (1767–1849) was a pupil of Gandon, and had a large architectural practice in Ireland, working on many country houses and provincial courthouses. He was helped in his work by his son, who took over the practice.

Not unnaturally the social and economic situation in Ireland which gave rise to the considerable expenditure on public buildings, and the aesthetic awareness which produced so much interest in the architects chosen for such work, affected buildings from such important *Ills. 77, 78* structures as the Custom House and the Four Courts right down to those of a more humble domestic nature. There is a balanced character and homogeneity about the residential houses and terraces in Dublin. There is also evidence of the competitive attitude felt by estate owners in the building or rebuilding of their houses during the second half of the eighteenth century and on into the nineteenth.

In Dublin this genuine enthusiasm combined with prosperity led to *Ill. 79* the laying out of the many fine squares and wide streets, and the same thing is reflected to a lesser degree in towns and cities throughout the country. And with the concern for style in the buildings themselves there came also a flourishing of interior decoration and adornment.

The plasterwork introduced early in the century by Italian craftsmen – notably the Francini Brothers – became a widespread craft in the country, practised by many highly accomplished Irish workers. The same effect was achieved by men like Bossi, who established a tradition in marble-work for fireplaces which was quickly imitated with remarkably good results. *Ill. 55*

And in sympathy with this, furniture, glass and silver all reached points of very considerable achievement. Glass factories flourished in Dublin, Belfast, Cork and Waterford, and the output, particularly from Cork and Waterford, was of a very high standard, with *Ill. 80* individuality of design and technique and with a remarkably successful period of operation, both before and after the Act of Union. And the last part of the eighteenth century saw the richest and most varied styles and designs in Irish silver, with the simple austerity *Ill. 81* of an earlier age being replaced by arcadian, rococo and bucolic attitudes which reflected not only the influences of Europe and England but also the growing prosperity of Ireland.

Unfortunately, it was short-lived. The historic occasions recorded by Francis Wheatley during his time in Ireland are evidence of the *Ill. 60* independence of spirit in the country at that time, but they do not

80 ANONYMOUS
Waterford glass
honey jar

reflect the growing discontent of the Catholics, the increasing tension which led to the formation of the United Irishmen and the Orange Order in the 1790s, and the bitter sense of frustration which brought about the Rebellion of 1798, with its bitter reprisals, and its worst result, the Act of Union of 1800. It was a failure made tragic by the fact that the enlightened moderation of Grattan's Parliament and its efforts to broaden the Protestant establishment were betrayed by frustrated idealism on the one hand and stubborn prejudice, political weakness and fear on the other. The results were to affect art no less than they affected the prosperity of Ireland. Yet, as in politics, it is possible to see in the development of art during the nineteenth century a more natural and a more native phenomenon than any that had evolved during the previous hundred years, and while the evolution was difficult and painful, it led finally to some of the best and most Irish artists of all.

81 ANONYMOUS
Pierced dish-cover,
Dublin 1773, silver

Landscape into art

In the summer of 1813 three rather bewildered Irish artists arrived in London. The eldest, George Petrie, inspected some of the city's *Ill. 92* exhibitions and public collections and then returned to Dublin. The other two, Francis Danby and James Arthur O'Connor, set out for Bristol. They arrived there with very little money, and it seems that Danby had to sell two of his watercolours of County Wicklow to pay for their lodging. Danby settled in Bristol, and from there went to *Ills. 95, 96* London about ten years later. O'Connor returned to Dublin, but *Ills. 82, 83* only for a few years. He was working in the west of Ireland five years after the visit to London, and thereafter he seems to have spent a great deal of his life travelling about, both in England and on the Continent. He was the least successful of the three artists, dying in near poverty, and he was undoubtedly the best.

In their destinies these three painters offer a miniature version of the fates of Irish artists throughout the nineteenth century. A number of them went to London. There were various reasons. Since the Act of Union, Dublin had lost much of its social lustre, and London was continually increasing its metropolitan magnetism. Painters like Sir *Ill. 97* Martin Archer Shee, Daniel Maclise, William Mulready, Samuel *Ills. 100–6* Lover, Richard Doyle and Adam Buck all gravitated to the capital, *Ills. 99, 120* and all made considerable contributions to the areas of art in which they worked. At the same time a rather different group of artists determined to establish and improve their position in Dublin and in the country generally by setting up an Irish academy of painters on the lines of the Royal Academy in London. Artists during the eighteenth century had been well served by the Dublin Society, with its purchases and grants, and its schools in drawing and sculpture and architecture. But it was, in the main, benevolent patronage from outside, not the corporate work of the artists themselves, and by the time the Dublin Society got round to the idea of holding exhibitions for artists generally, the artists had decided to do it for themselves. They tried various group endeavours during the second half of the eighteenth century and the early years of the nineteenth. The Society of Artists in Ireland was formed in 1765. In 1773 a splinter group set

up, calling itself the Academy of Artists. Between 1780 and 1800 there seem to have been no public exhibitions in Dublin, and then in the latter year the Society of the Artists of Ireland was formed only to split in 1812 into the Irish Society of Artists and the Society of Artists of the City of Dublin. These two amalgamated again in 1814 into the Hibernian Society of Artists, which a year later divided once more into the Artists of Ireland and the Hibernian Society, only to come together yet again in 1816, and to hold joint exhibitions under the auspices of the Dublin Society until that society closed down its exhibition premises when it purchased Leinster House. This rather Irish state of affairs was ended in 1823 by the formation of the Royal

Ill. 62 Hibernian Academy. William Ashford was its president, and among its founder members were Martin Cregan, William Cuming, J. G. and T. J. Mulvaney, Joseph Peacock, Thomas Sautelle Roberts and William Mossop, the medallist. Three years later Petrie was made an associate member, and in 1828 a full member. The RHA will be mentioned again, but it is worth pointing out at this stage that throughout the nineteenth century, and for the greater part of the twentieth, the Academy, in spite of neglect, disagreement and a schism in the 1850s not unlike the many group rivalries of the period 1800–20, has been at the centre of artistic activity in Ireland. Regrettably, what W. G. Strickland, in his *Dictionary of Irish Artists*, had to say in 1913, still applies:

> From the time of its foundation to the present day the Academy has struggled against adverse circumstances, partly from the neglect and apathy of the public and partly from the difficulty which was found in filling the ranks of the Academicians with artists who could paint. The history of art in Ireland – as can be seen from the account of artists given in the foregoing pages – shows that young artists of talent and ambition would not remain where there was no outlet for showing their powers, but emigrated to London.

Fortunately, during the first half of the nineteenth century, there were many artists who did not emigrate. But not all of them became

Ills. 82, 83 good members of the RHA. Some, like James Arthur O'Connor, fixed their sights neither on London nor Dublin. And the phenomenon which at first permitted, and then gradually encouraged, these painters was the rise of landscape painting.

From the quite difficult beginnings in the second half of the eighteenth century, a growing appreciation of the decorative as well

94

as the dramatic value of landscape painting had given purpose as well as direction to many different artists, working in oil, watercolour and gouache. They had been helped by the growing taste for views published in book form, and they had been provided with the regular and increasingly reliable 'market' of the annual Royal Hibernian Academy exhibitions. There was also a growing interest in the idea of the 'picturesque'. The change, the importance of which is very great, liberated the artist from the confines of place. His first consideration ceased to be the accurate portrayal of a piece of country and became the sympathetic creation of a work of art. The two are not, of course, mutually exclusive. It is solely a question of priorities. But when James Arthur O'Connor painted *The Poachers* towards the end of his *Ill. 82* career, one in which he had suffered almost continual neglect, he demonstrated once again his life-long belief in a kind of landscape that liberated the painter from the limited confines of topographical patronage, whether in oils, watercolours or engravings, and gave him the right to paint pictures in which the mood and atmosphere, the time of day and the season of the year, the originality of composition and the communication of an event or moment in time mattered more than the locality and who owned it.

James Arthur O'Connor (1792–1841) was the son of an engraver *Ills. 82, 83* and print-seller and is said to have received lessons in painting from

82 JAMES ARTHUR O'CONNOR *The Poachers*

William Sadler, who was some ten years his senior. O'Connor's development as a painter was slow. His early landscapes have poor tonal balance, and are dark without having any of the luminous quality of the later paintings of gorges and glens to compensate. The influence of Sadler, fortunately, was slight, and it is probable that O'Connor taught himself, a great deal of the time with reference to the prints which his father sold. Among these he must have seen many of the engravings of seventeenth-century Dutch landscape, and if any influence is paramount in his work it is that of Hobbema and his contemporaries. It can be seen both in his figures and in his composition, and on occasions his trees seem to derive directly from the Dutch Master, after whom O'Connor was nicknamed 'the Irish Hobbema'. After returning from Bristol, O'Connor worked in Dublin, but without much success, and it was only in 1818 that he got his first and only important commission when he was asked by the Marquess of Sligo to visit Westport and paint landscapes there. He spent a year and a half at Westport House and on other estates in the west of Ireland, and some of his most impressive paintings were done at this time: large views of Westport, Clew Bay, Mount Browne, Finlough, and the lakes and mountains of Connemara. Impressive as they are, however, they are fundamentally alien to O'Connor's

Ill. 83

83 JAMES ARTHUR O'CONNOR *View of Westport House*

nature. They are commissioned works, formal and rather stilted, composed to fit in a house or 'view' for the Marquess or some other patron, and lacking the warm intimacy in which O'Connor's own wayward choice of subject and approach would have resulted. The importance of these works in his development, on the other hand, is very considerable. They gave O'Connor the chance to develop his technical range, to experiment with different types of landscape, to work free from financial worry and in the process to discover the sort of landscape painting he really wanted to do. He returned to Dublin for a year or so, married, and in about 1821 went to London. For the last twenty years of his life he travelled a great deal, but continued to send pictures to the Royal Academy, the British Institution and the Society of British Artists, as well as the RHA in 1836 and 1840. He visited Brussels in 1826, and in 1832–3 he was on an extensive tour through Paris and into Germany, painting a number of landscapes along the Rhine. He seems to have visited Ireland at least twice during the 1830s, but was living in London, still not able to sell much of his work, and suffering in the last years from weak sight and ill-health.

O'Connor was a careful and meticulous painter. He worked often from small and carefully drawn sketches in sepia pen and wash, and occasionally in watercolour, and both the British Museum and the National Gallery of Ireland have small collections of these, the former's relating to Sligo and Germany, the latter's to London and Kent shortly after O'Connor's arrival there. His best paintings have a great sense of 'moment' about them with a well-drawn shepherd or labourer coming home through the stillness of a summer's day, a boy fishing beside a stream or in a glen, or the more stormy aspect, perhaps without figure at all, of such 'tourist attractions' as the Devil's Glen or the Glen of the Dargle. O'Connor's tone and colour are balanced, fresh and vivid. His composition is good, and his little figures in their red waistcoats, which are almost a signature in his paintings, are well placed and well drawn.

While O'Connor may be regarded as the father of modern landscape painting in Ireland, he had few followers or imitators just as he had few buyers or patrons. At the same time a group of watercolourists and landscape artists did emerge who achieved in their work the same freeing of their art from the restrictions of the late eighteenth century. One was George Chinnery (1774–1852). He was *Ill. 84* not Irish, but lived and worked in Dublin from about 1795 to 1802, and was influential among Irish painters of the period. He did

97

portraits, miniatures and landscapes in watercolour, the latter of which show the influence of Rowlandson. He also married while in Dublin, and had two children, but deserted his family and set out for the Far East where he spent the rest of his life, partly doing formal portraits, but for the most part engaged in prolific graphic work of a very high standard. Chinnery was a first-class draughtsman and graphic journalist, and the many thousands of his pencil and pen drawings in the Victoria and Albert Museum and other public and private collections have a uniquely vivid and immediate quality.

Ill. 85 William Sadler (1782–1839) taught O'Connor, though not for long, and was easily outstripped by the younger man in every respect. At the same time Sadler had a lively and attractive style, with a good sense of movement in his figures. Some of his best paintings are his most simple rural views, but he worked fast and easily, and turned his hand to a wide range of subjects, including the portrayal of buildings, historic events and large views of towns and cities.

Ill. 86 One other lone figure of this period was Gaspare Gabrielli (*fl.* 1805–30), an Italian decorative artist brought to Ireland in 1805 by Lord Cloncurry and employed in the decorating of Lyons House in County Kildare. He married Lady Cloncurry's maid and settled in Dublin, and during the period 1809–14 he exhibited over sixty Irish landscapes, very few of which seem to have survived. Many of them were in gouache, his favourite medium, but his oils, too, are very fine, and he was thought better than T. S. Roberts in his day.

84 GEORGE CHINNERY *Coastal Scene near Dublin*

85 WILLIAM SADLER *King's Bridge and Kilmainham Gate, Dublin*

86 GASPARE GABRIELLI *Irish Landscape*

The landscape artists in watercolour during the first half of the
Ill. 87 nineteenth century were led by John Henry Campbell (1757–1828), a
much under-rated artist, poorly represented in the principal public
collections by faded and damaged drawings, and whose landscapes in
oil, some of them very competent, are virtually unknown. He was a
rather formal artist in his composition, carefully constructing a
'frame' of foreground trees and foliage for his main subject. But for a
watercolourist working as early as he did, his washes are beautifully
clear, fresh and vivid, his technique open and free, and his sense of
light and perspective impeccable. His view of Dublin Bay and
Ill. 87 Harbour from Dundrum is one of a series done in 1804, the period of
his finest work. Campbell was influenced by Sandby, and did some
copies of his watercolours. He exhibited regularly in Dublin, but not
with many works, and it would seem, from the number of his
watercolours which come up at country auctions in large houses, that
Campbell travelled round Ireland giving lessons in art to the families
of the landed gentry.

Campbell's daughter, Cecilia Margaret Campbell (1791–1857),
was one of Ireland's first women artists, and an able painter both in
watercolour and oil. Her watercolours are not up to the same
standard as those of her father, tending to be rather flat, and with
weakly drawn figures, but her washes are good, and she has a spirited
and individual way with trees and foliage. She married George Nairn
(1799–1850), a competent and distinctive painter of animal portraits.
Ill. 88 Henry O'Neill (1798–1880) was a landscape artist of considerable
power who was trained in the Dublin Society schools, probably
under Henry Brocas, and then taught drawing. Some of his best
landscapes were published as coloured aquatints in the 1830s, and he
also painted some extensive canvases in oil. In later life O'Neill
became involved in politics and archaeology, and his painting
suffered, falling much below the early high standard. His associate in
Ill. 89 some of the publishing ventures of the 1830s, Andrew Nicholl
(1804–86), was a northern artist, born in Belfast, and active as a
landscape artist in northern Ireland, England and Dublin. He taught
painting in Ceylon for a time but returned to London, then to Dublin
and Belfast. He is a good watercolourist, quite close in style to Petrie
and O'Neill, and his handling of open landscapes and coastal scenes, as
well as mountains and trees, is highly competent. He influenced other
watercolourists in northern Ireland, particularly the accomplished
amateur, James Moore (1819–83).

87 JOHN HENRY CAMPBELL *View of Dublin Bay*

88 HENRY O'NEILL *The River Blackwater near Fermoy*

Edward Hayes (1797–1864) painted both portraits and landscapes in watercolour. His portraits are close in style to the enlarged miniatures of Chinnery and the early, full-length portrait drawings by Daniel Maclise. His landscapes tend to be weak in perspective and loose in composition. George Grattan (1787–1819) started out by painting rather charming rustic scenes, but graduated to historical painting for which he was not as well equipped. *A Village Merrymaking* in the National Gallery of Ireland is a lively if rather clumsy example of his work. George Holmes was another artist active in Dublin at the turn of the century, and numerous views done by him were engraved. William Henry Brooke (1772–1860) was the son of an Irish historical painter of the eighteenth century, and did some Irish landscapes which were published in various periodicals and books.

Michael Angelo Hayes (1820–77) was an estimable artist whose watercolours are well drawn, with good perspective and composition. He enjoyed drawing and painting horses, and was responsible for the Bianconi 'Car-Travelling' prints, as well as a number of other engraved works.

During the whole of the first half of the nineteenth century the teaching of landscape painting in the Dublin Society schools was in the hands of the Brocases, Henry Senior and Junior, and they came

Ill. 84
Ill. 105

Ill. 90

89 ANDREW NICHOLL *Mourne Mountains from the Road near Castlewellan*

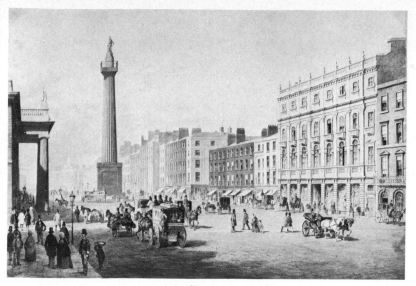

90 MICHAEL ANGELO HAYES *Sackville Street, Dublin*

91 SAMUEL FREDERICK BROCAS *Post Office and Sackville Street, Dublin*

from a family of artists, of whom the best known was Samuel
Frederick Brocas (1792–1847). His views of Dublin were etched by
his brother, Henry Junior (1798–1873), and published in 1820. They
are among the most spirited views of Dublin, full of life and activity,
although in the drawing and the engraving much inferior to Malton's
work. The father, Henry Brocas Senior (1762–1837), was a better and

Ill. 91

far more prolific engraver than his son, and an artist of some merit in both watercolour and oils. The Victoria and Albert Museum has an interesting sketchbook of drawings by William Brocas (1794–1868), but the National Gallery of Ireland has reattributed a painting of Bray Head formerly ascribed to him to his brother, Samuel Frederick.

Ill. 92

George Petrie (1790–1866) followed a career not unlike that of Henry O'Neill, although rather more distinguished. His early watercolours are fine, soft landscapes with broad washes and an excellent sense of light and distance. But his graphic ability was noticed by various publishers, and he was engaged in a number of ventures as a book illustrator. This curtailed his scope and narrowed his vision. It also led him into dedicated and extremely valuable work as an archaeologist, a member of the Royal Irish Academy, and a member of the Royal Hibernian Academy, of which he became librarian and eventually president. He was involved in the Ordnance Survey of Ireland, and also did much research into Irish music. His watercolour painting suffered as a result of all this, and his early work is generally considered to be his best.

George Petrie was preceded in the post of president of the RHA by two fine portrait painters, William Cuming (1769–1852) and Martin Cregan (1788–1870). Cregan was the first and only pupil of Martin

92 GEORGE PETRIE *Gougane Barra*

Archer Shee, and a friend of Constable and Landseer. He returned to *Ill. 97*
Dublin in 1822 and worked successfully in the city for the rest of his
life. His portraits are lively, sensitive and attractive, and he was
particularly good at painting pretty women. Cuming was also highly
thought of for his portraits of women, and was a leading artist in
Dublin for the first thirty years of the century.

Other painters of the period working in Dublin include the
Mulvaneys: Thomas James (1779–1845), John George (1766–1838)
and George Francis (1809–69), son of T. J. and the best of the three,
although his fame rests primarily on his work in getting a National
Gallery established and his management of it as its first director.
Joseph Patrick Haverty (1794–1864) was a Galway painter who did
much of his work in Limerick, as well as exhibiting in Dublin and
London. Nicholas Joseph Crowley (1819–57) painted portraits in *Ill. 93*
Dublin, but concentrated his energies on Belfast. His self-portrait is in
the Ulster Museum there. The work of Bernard Mulrenin also
belongs to this period.

The leading miniaturist after Horace Hone, who continued *Ill. 68*
working until 1822, was John Comerford (1770–1832). He was an
energetic and successful artist, and many of his miniatures and small
drawings are excellent. He stood aloof from the groups of artists in
Ireland, and like James Barry he despised academies for artists.
Strickland quotes him as saying, 'Those who encourage young men
to become artists were doing a real and substantial injury to society,
they were destroying very excellent carpenters, smiths and house-
painters, and creating a class of unfortunates who never would be
capable of doing any good for either themselves or others,' and his
sentiments have frequently been repeated, often by the best of
painters. Charles Robertson (1760–1821) was another excellent
miniaturist, and he trained his daughter, Clementina (1795–1853), in
the same art.

It is of interest that no less than three of the eight sculptors
employed on the Albert Memorial were Irish, the most important
being John Henry Foley (1818–74), who was responsible for the
bronze statue of Prince Albert and for the group representing 'Asia'.
Foley is the most important sculptor Ireland has ever produced. His
work ranges from the relatively intimate Oliver Goldsmith outside *Ill. 94*
Trinity College to the monumental O'Connell memorial in
O'Connell Street. His equestrian statue of Viscount Hardinge is a
superb epitome of the Victorian age in England, with its ideals of

imperial responsibility, and Foley's response to this atmosphere was a conscientious and, at times, inspired one. Patrick MacDowell (1799–1870) was a Belfast sculptor, and responsible for the 'Europe' group on the memorial, as well as many statues and busts in Belfast, Dublin and London. John Lawlor (1820–1901) and Samuel Ferris Lynn (1834–76) also worked with Foley on the Albert Memorial. John Edward Carew (1782–1868) was another important Irish sculptor of the period who worked mostly in England. Others, whose names only can be given, include Christopher Moore (1790–1863), John Hogan (1800–58), Peter Turnerelli (1774–1839), Joseph Watkins (1838–71), the Gahagans, Laurence (1756–1817) and Sebastien (1800–35), Thomas Kirk (1781–1845) and finally Joseph Robinson Kirk (1821–94).

Ills. 95, 96

Ill. 87

The last and perhaps the most interesting group of artists of this period are those who, like Francis Danby, left Ireland to make their reputations in London. Francis Danby (1793–1861) painted both in watercolour and oils. His watercolour technique developed out of a straightforward, competent landscape style, not unrelated to work by John Henry Campbell. His early watercolour drawings show a practical attention to detail which was greatly enriched in later work by his sense of depth and subtlety. His painting in oil is quite another

93 NICHOLAS J. CROWLEY
Self-portrait

94 JOHN HENRY FOLEY
Oliver Goldsmith

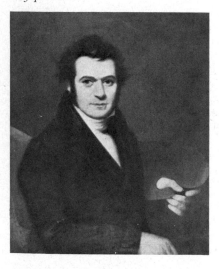

95, 96 FRANCIS DANBY *Mill near Beggar's Bush* and *Liensford Lake, Norway*

matter. In most of his oils Danby seems to be attempting 'sublime' subjects. Not only are these often bathetic, *The Opening of the Sixth Seal* in the National Gallery of Ireland being a fair example, they are also painted in harsh and lurid colours which have suffered with age. Danby's fascination with sunset has been his undoing in many pictures, even the straightforward seascapes. Occasionally, as in

Ill. 96 *Liensford Lake, Norway* in the Victoria and Albert Museum, good paintings have survived. Martin Hardie, in his *Water-Colour Painting in Britain*, describes Danby as one of the most interesting and gifted artists of the Romantic period, and in watercolours this is very true, both in the artist's technique and his vision.

Ill. 97 Sir Martin Archer Shee (1769–1850) had already been painting in London for twenty-five years when O'Connor, Petrie and Danby paid their brief visit, and after much struggling and difficulty had achieved an important position as a portrait painter. He came originally from Dublin, although his family had roots in Kilkenny and Mayo, and after training in art at the Dublin Society schools he established himself in the city as a portrait painter. Gilbert Stuart advised him to go to London, which he did. He was helped by another Irish artist, Alexander Pope (1763–1835), and by Edmund Burke, and by 1800 was a well-established London portrait painter. By the time he was made President of the Royal Academy after

97 SIR MARTIN ARCHER SHEE
Self-portrait

98 RICHARD ROTHWELL
A Smiling Child

Lawrence's death in 1830, Shee had a considerable reputation as a writer as well as an artist.

Shee's earliest work is often regarded as his best, and certainly the simple directness of the self-portrait has a quite different and rather *Ill. 97* more immediate appeal than the splendid and flamboyant portrait of King William IV. The first dates from 1794, the second from the 1830s. Yet the second, and the many others painted during the artist's maturity, have many of the best qualities of drama and portent which Shee understood so well and presented with vigour and technical excellence. His portrait of Thomas Moore in the National Gallery of Ireland is a sensitive study somewhere between the self-portrait and the King William.

Richard Rothwell (1800–68) was an artist who, like Barret, lacked the self-confidence and strength of character to withstand the bad advice of artists who wish to persuade others to follow their style, however inappropriate. He would have been an excellent portrait painter, working much in the style of Lawrence, whose pupil he was, as his *A Smiling Child* shows. But he felt ignorant about the great *Ill. 98* painters of the past, decided that he should try to emulate them, and was persuaded by B. R. Haydon to undertake historical art. *Callisto*, in the National Gallery of Ireland, is a good example of how mistaken this decision was. Rothwell's career became a fragmented and psychologically rather tortured one, and the fact that he regarded *Callisto* as his finest work is indicative of the distortion of his vision. His portrait of Mary Shelley in the National Portrait Gallery is a fine and sympathetic work, and so are those of Matthew Kendrick and Gerald Griffin in the National Gallery of Ireland. Rothwell died in Rome, and was buried beside Keats.

Amelia Curran (1775–1847), the eldest daughter of John Philpot Curran, deserves mention for one striking portrait, that of Percy Bysshe Shelley in the National Portrait Gallery. It is an unfinished work, but for an amateur artist it is remarkably sympathetic.

Two highly accomplished miniaturists worked in London at this time, Samuel Lover (1797–1868) and Adam Buck (1759–1833). Buck *Ills. 99, 101* came from Cork, and worked there until his move to London in 1795. Many of his miniatures are full-length, either standing or seated, and there is a fine self-portrait in the Courtauld Institute, as well as an excellent set of profiles and portraits of two girls, one seated and one standing, signed and dated 1800. His posing in these pictures is somewhat rigid. In his lifetime he became better known, however,

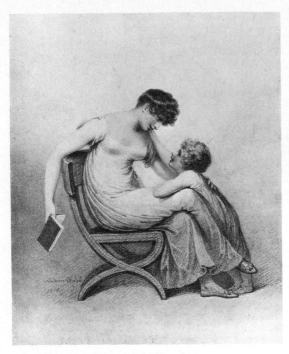

99 ADAM BUCK '*Mama don't make me beg in vain,/Pray read that pretty book again*'

100 WILLIAM MULREADY *Bathers Surprised*

Ill. 99 for his 'fancy subjects', many of which were engraved. These have a certain innocent charm, though their aesthetic relevance is somewhat questionable.

Samuel Lover's career was rather more varied than Buck's, but he was not so good an artist. His miniatures are close in style, and he also did small full-lengths, but these tend to be larger and more elaborate, *Ill. 101* the heads carefully painted, the rest sketched in. His self-portrait in the National Gallery of Ireland is a good example of his work. He was also a novelist and musician, and towards the end of his life earned considerable sums of money giving what he called 'Irish Evenings', made up of his own compositions.

The last two artists to be considered in this chapter are probably the two Irish painters who made the biggest impact on English art during *Ills. 104–6* the first half of the nineteenth century, Daniel Maclise (1806–70) and *Ills. 100, 102,* William Mulready (1786–1863). Both are under-rated painters. *103* Mulready started painting very early, and had already received lessons from John Graham, Haynes and Banks the sculptor before

going to the Royal Academy school at the age of fourteen. He came originally from Ennis, County Clare. He was a meticulous painter, and many slight, often tiny, preparatory sketches for details in his paintings exist. He once told Samuel Palmer that 'all the best artists had begun with what is called niggling.' And it even went so far that he would produce full-size watercolour sketches of his paintings before actually tackling his canvases. But he was usually able to offset the danger of laboured appearances in his work by the atmosphere of action and suspense which his own style of genre painting led him to. In his *Bathers Surprised*, the pink-fleshed and voluptuous nudes are *Ill. 100* presented in somewhat puritanical environment by the story which the picture tells, a story which is going on *behind* the central figure, as if they were a backcloth, which in fact they are. There is a similar, but rather more natural painting in the same style in the Municipal Gallery of Modern Art in Dublin, and others elsewhere, as well as a fine preliminary drawing of four nude girls bathing in Edinburgh. Perhaps Mulready felt he had to dress his nudes in genre clothing. Certainly he was never as brazen as William Etty.

Mulready's best work was in the straightforward 'telling of a story'. *The Last In* is an excellent example of this, and one of *Ill. 103* Mulready's most charming pictures. 'Charm' and 'delight' are words that one applies frequently to his art. He paints with great warmth and sympathy, achieves excellent tension, excitement and drama, and yet rarely steps beyond the most ordinary of events, mostly

101 SAMUEL LOVER *Self-portrait*

102 WILLIAM MULREADY *Self-portrait*

concerned with children, family, animals and simple domestic squabbles, dramas and frustration. A third area in which Mulready was active was landscape, in which he produced a number of good but unpretentious works. He also painted some portraits, among them a very slight but excellent picture of his father in the National Gallery of Ireland, and a good though unfinished self-portrait.

Daniel Maclise started out as a portrait artist, drawing and painting in watercolour small cameo portraits, some of which are in the British Museum, signed with an early version of his name, McClise. He was born in Cork, almost certainly in 1806 although the date is disputed. His early work was done there, and he was 'discovered' by Walter Scott when he did a rather successful sketch of the writer, a version of which is also in the British Museum. On Scott's advice he went to London and studied at the RA schools. He still continued portrait painting, and produced many of his literary friends, both in small drawings which appeared in *Frazer's Magazine* under his pseudonym, 'Alfred Croquis', and in oils, one of the best being of his lifelong friend, Charles Dickens.

But Maclise was attracted by narrative painting; his friendship with writers and actors gave a somewhat literary bias to this interest, and led him to paint many Shakespearean subjects, one of the first being *Malvolio affecting the Count*, which was his first picture submitted to the RA in 1829. Throughout the 1830s and 1840s he

Ills. 104–6

Ill. 105

103 WILLIAM MULREADY
(left above) *The Last In*

104 DANIEL MACLISE
A Winter Night's Tale

105 DANIEL MACLISE
Portrait of Charles Dickens

106 DANIEL MACLISE *The Marriage of Princess Aoife and Strongbow*

painted large canvases with immense technical skill and attention to detail, and managed at the same time to maintain unity and balance in subject, colour and composition. The best of these narrative pictures are those which are most intimate, however, and some of them are superb paintings, rich and warm in colour and tone, intense in statement and beautifully composed. Among them is one in the Walker Art Gallery in Liverpool, *Madeline after Prayer*, and *A Winter Night's Tale* in the Manchester City Art Galleries. Some of Maclise's straightforward subject pictures, such as *The Falconer* in the Municipal Gallery in Cork, are also fine works.

Ill. 104

In the late 1850s Maclise was engaged on the decorations for the new Houses of Parliament, and in 1859 he completed his wall painting of *Wellington meeting Blucher*. Five years later he finished his *Death of Nelson*, but although he had arranged to do others for the building he declined. *The Marriage of Princess Aoife and Strongbow* was to have been done for Westminster as well, but was not included in the scheme. The canvas picture, which is on the same massive scale, is probably his largest oil painting. He has been much maligned, both on account of technique and inspiration, and he has suffered from countless appearances in school textbooks. He is an important artist, and an influential one, and in his best pictures a sympathetic and highly effective creator of atmosphere and tension.

Ill. 106

The Celtic revival

In his poem 'The Municipal Gallery Revisited', William Butler Yeats attempts to draw together the threads of the past as they appear to him in the paintings, and as they relate to the ideals of J. M. Synge, Lady Gregory and himself. What he wrote of Mancini's portrait of Augusta Gregory might well have been the poet's comment on the whole era and its generation of Irish men and women:

> But where is the brush that could show anything
> Of all that pride and that humility?
> And I am in despair that time may bring
> Approved patterns of women or of men
> But not that selfsame excellence again.

Yeats's appeal as a poet lies to a great extent in his sense of *le temps perdu*, and his ability to recapture and synthesize the multiple threads of the past. He draws together John Butler Yeats, John Lavery, Hugh Lane, even Sargent, Mancini, Shannon, and he evokes a period out of the past. But how personal is it, and how reliable? The poet celebrates 1916. But what notion had he of its coming? To what extent can the art of a period, in this instance from the Famine to the Rising, have more than accidental relevance to history as it pursues its highly individual route into posterity or oblivion?

Ills. 125, 127–9

 The only certain thing about Irish art in the period from 1850 to 1916 (an arbitrary date, it must be admitted, but a convenient one), is its diverse and fragmented nature. No simple pattern emerges. The only names to dominate are the highly individual ones of Nathaniel Hone, Roderic O'Conor, Walter Osborne, John Butler Yeats, Sir William Orpen and Sir John Lavery. There is added diversity of media, with the important development of Irish stained glass. But beyond the loosely corporate activity of groups of painters, such as those working in Antwerp, there is little or no real unity, a situation to be explained by the fact that the most important styles of painting pursued – landscape, genre and historical painting – were basically solitary.

Ills. 107, 108
Ills. 109–14,
127–9
Ills. 123–5

107 NATHANIEL HONE *Pastures at Malahide*

Ills. 107, 108

Ills. 65, 66

The greatest Irish landscape painter of the period, Nathaniel Hone (1831–1917), epitomizes this situation. He was a descendant of Berkeley Hone, brother of the eighteenth-century portrait painter, but began life as an engineer, taking up painting only when he was twenty-two, and going to study it in Paris under Adolphe Yvon, and later under Thomas Couture. He then moved to Barbizon, and worked there in close contact with Jean-François Millet and Henry Harpignies, painting landscapes exclusively, and, apart from visits to the Mediterranean, remaining in that famous village for close to twenty years. In about 1875 he returned to Ireland, and spent the rest of his life in north County Dublin, painting and farming. He did not really need to sell his work in order to live, and apart from his regular submissions to the annual exhibition of the RHA, of which he became a member in 1880, Hone did not show widely, tending to remain aloof and indifferent towards critics and other painters who were not his friends. He accepted the RHA Professorship of Painting in 1894 which he held until his death.

While Hone's approach to landscape is distinguished by its Barbizon traits, his application of them to his Irish environment is assured, sympathetic and profound. His horizon-line is generally low, giving him adequate space for his magnificently painted skies and for the immensely subtle play of light and colour which is so essential a

108 NATHANIEL HONE *Off Lowestoft*

part of Irish landscape. *Pastures at Malahide* is Hone at his best. His *Ill. 107* composition, in which the sky is dominant, is simple and powerful. His colour, while restrained, is fresh and vital. And in spite of the peaceful and unified tranquillity of the subject, the painting has enormous strength and vigour.

It was Thomas Bodkin's opinion, in his *Four Irish Landscape Painters*, published three years after Hone's death, that less than a hundred of Hone's oil paintings were in private collections. The rest, some 550 oils and nearly 900 watercolours and drawings, were left to the National Gallery of Ireland, where the greater part of them are stored away. The majority will never be shown, and Hone will never be 'marketed', a fate which will always limit appreciation to a few admirers, and make possession an eternally circumscribed privilege.

Hone also painted many seascapes, not only near his home, in the west of Ireland, but also in Britain and abroad. They again reveal his simple but assured mastery of composition, light and colour. His watercolours are constant annotations of light and shade, and of the ever-changing patterns of colour in landscape. They are mostly jottings, of the sort Constable took, but when Hone does become expansive his washes and colours are excellent.

In Roderic O'Conor (1861–1940), France attracted another Irish *Ills. 109–11* painter of great range and distinction, who went there in his early

109 RODERIC O'CONOR
A Young Breton Girl

110 RODERIC O'CONOR
Self-portrait

111 RODERIC O'CONOR *Field of Corn, Pont-Aven*

twenties and never came back. O'Conor's origins are obscure, and his life, to say the least, that of a recluse. He hated art dealers, and rarely exhibited his pictures or sold them. In 1906 he gave his *A Young Breton Girl* to the New Municipal Gallery of Modern Art in Dublin, but in general, work left his studio only to private buyers, among them Somerset Maugham, who had several of his works, which O'Conor parted with somewhat ungraciously. O'Conor was a friend of Gauguin, and lived and worked at Pont-Aven, where some of his finest landscapes were painted. Gauguin wanted him to go to the South Seas, but O'Conor declined. He had discovered, in the wild and isolated landscape of Brittany, a totally absorbing subject for his art, and he was lucky enough to be able to settle for that. In the 1920s the English painter, Matthew Smith, worked with O'Conor for a time, and was, by his own admission, influenced more by him than by any other artist.

Ill. 109

There are three not very distinct periods in O'Conor's work. The first is the most impressionist, from about 1889 to 1900, when O'Conor was painting strongly under van Gogh's influence, though whether he knew van Gogh is not clear. These early pictures employ a stripy technique, not unlike van Gogh's, with quite heavy paint, but relatively subdued colours. From 1900 to 1910 is the artist's best period. His colours become rich, strong and beautifully balanced, and a highly distinctive palette emerges in these canvases. After 1910 his work becomes more diverse, his style ranges more widely, possibly with a certain loss of intensity.

His self-portrait reveals something of O'Conor's introspective and anti-social nature, as well as his very French appearance, his sallow complexion, dark hair and drooping moustache. His wife was also an artist.

A group of Irish artists also worked in Belgium, and this 'Antwerp School' of the 1880s was led by Walter Frederick Osborne (1859–1903), the son of William Osborne (1823–1901), himself a good artist who painted mainly animals and hunting scenes. The younger Osborne was trained by the RHA and was a frequent prize-winner. He studied in Antwerp under Verlat in 1882–3, and after his return he spent ten years travelling and painting landscapes in England, Spain, Brittany and Holland, as well as urban scenes. His view of the promenade in Hastings is a finely composed picture, with the excellent impression of golden light falling on the buildings in the background, and the finely grouped foreground figures.

Ills. 112–14

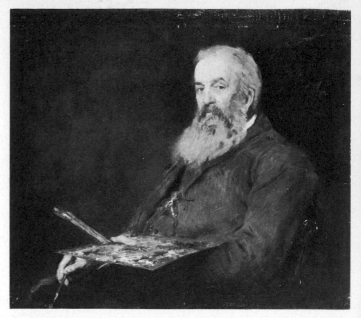

112 WALTER OSBORNE
Nathaniel Hone

His early landscapes, such as *Apple Garden at Quimperlé* in the National Gallery of Ireland, have a wonderful, timeless innocence about them, and his painting of children, from the very beginning, was accomplished. This is particularly apparent in his poignant Dublin street scenes, in which he concentrated on the forlorn and hopeless poverty of the areas around St Patrick's Cathedral, the Coombe and the various city markets. There is splendid atmosphere

Ill. 114 in *Saint Patrick's Close, Dublin*. The greyness, the grime, the smell, the squalor, are almost palpable, and the foreground figure of the boy with his whistle, and then another child, and yet another, provide a subtle entry into the damp, bleak street, with its stalls and derelict houses. These views belong to the late 1880s and 1890s. At this time Osborne also took up portrait painting, and while much of the work involved attracted him far less than did landscape, he was good at it, and on occasion produced very fine likenesses, among them his excellent portrait of Nathaniel Hone. Osborne produced a number of watercolours, although his technique was somewhat muddy. His general style was becoming a good deal freer at the time of his early death from pneumonia.

Ill. 115 Joseph Malachy Kavanagh (1856–1918) was a friend of Osborne and one of the artists who studied at Antwerp. He seems to have been rather more precise and clear-cut in his composition than Osborne,

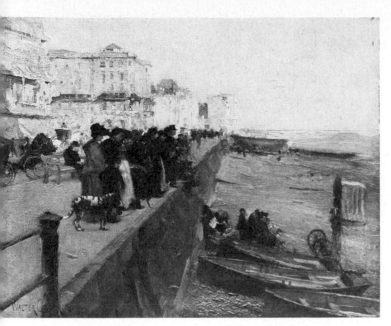

113 WALTER OSBORNE *Hastings*

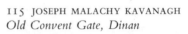

114 WALTER OSBORNE
Saint Patrick's Close, Dublin

115 JOSEPH MALACHY KAVANAGH
Old Convent Gate, Dinan

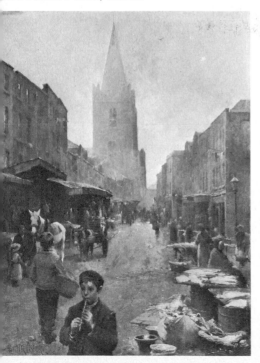

but he lacked the inspiration of his friend's painting, and the majority of his works are rather limited in range. He handled figures poorly, but his sense of light was superb, and some of his best works are his simple seashore pieces, with their low horizons and massed, sun-drenched clouds, their pinks and golds reflected in wet sand.

Many of the Antwerp artists went on to Brittany to paint. Others in the group include Dermod O'Brien (1865–1945) who became president of the RHA in 1910. He painted many good, though rather low-key landscapes; Richard Thomas Moynan (1856–1906), a technically able painter who wandered off into rather indecisive genre pictures; Henry Allan (1865–1912), Nathaniel Hill and Frank O'Meara.

A more diverse group of landscape painters were working in Ireland at a slightly earlier period, including three excellent painters *Ills. 116, 117* of seascapes, John Faulkner (fl. 1852–87), Edwin Hayes (1820–1904) and George Mounsey Wheatley Atkinson (1806–84). Faulkner's watercolours are usually quite large and spirited in treatment, often *Ill. 116* showing stormy seas, as in his *Off Cape Clear, Co. Cork.* He also painted in oils, but seems to have preferred watercolour. He painted in the United States for a while, and in London; but his life was somewhat obscure, and not many of his works are known. Edwin *Ill. 117* Hayes studied in the Dublin Society's schools, and then went to sea, though always with the determination of becoming a marine painter. He worked in Dublin until 1852, and then went to London. His sea paintings have great realism and accuracy. Atkinson was a Cork

117 EDWIN HAYES *Entrance to Cardiff*

artist, self-taught, and tending to paint 'portraits' of ships which are often sought after more for their subject than their creator. J. Glen Wilson, the Belfast artist, also painted good marine pictures.

William Davis (1812–73) is an important Irish landscape artist who was born and trained in Dublin, and began by working in the city as a portrait painter. Fortunately he was unsuccessful, and turned to landscape painting, producing his fine *Junction of the Liffey and Rye, near Leixlip* before leaving Dublin to live and work in Liverpool. There his landscape technique developed considerably, and he acquired a highly individual approach to colour and detail, very rich and rather strange in atmosphere and feeling, and close to the landscape style adopted by some of the Pre-Raphaelite landscape artists. There is great mood in his painting, much of which derives from his almost surrealist treatment of some of the figures. *Ill. 118*

Thomas Bridgford (1812–78) was an artist whose style was quite close to that of Davis. He painted genre pictures and portraits rather than landscapes. Augustus Nicholas Burke (1838–91) painted good though less individual landscapes than Davis, some of them in Brittany. William Howis (1804–82) painted landscapes in the style of James Arthur O'Connor, and even did a number of good copies of O'Connor's work, many of which were sold as the work of the earlier *Ills. 82, 83*

116 JOHN FAULKNER *Off Cape Clear, Co. Cork*

118 WILLIAM DAVIS *Junction of the Liffey and Rye, near Leixlip*

artist. John O'Connor (1830–89) was initially a theatre call-boy, but turned to scene painting and landscapes, at which he became highly accomplished, working throughout the British Isles.

Among landscape painters in watercolour were William Craig (1829–75); James Mahony (1810–79), who painted fine and extensive scenes in Dublin, some of them interiors; Bartholomew Colles Watkins (1833–91), who was primarily a painter in oils, but whose watercolours tend to be better and more sensitive; Alexander Williams (*d.* 1930); Mildred A. Butler and Rose Barton. Percy French (1854–1920) started out from Trinity College, Dublin, as an engineer, but seems, not unlike Samuel Lover, to have spent a delightful lifetime composing, singing and painting watercolours. Another writer who painted with some distinction in watercolour was Edith Œ. Somerville (1858–1949).

Jeremiah Hodges Mulcahy (*d.* 1889) was a Limerick painter whose work is detailed and meticulous, almost eighteenth century in style. His composition was occasionally weak and stilted, but his *Curragh Chase* in the National Gallery of Ireland is a good example of his

124

work. Alfred Elmore (1815–81) was a Cork painter, trained in London and Paris, and became a successful artist of genre pictures.

Sir Frederick William Burton (1816–1900) was a very accomplished watercolourist and draughtsman whose best work was probably in portraiture. His *The Aran Fisherman's Drowned Child*, in the National Gallery of Ireland, is a melodramatic but well-drawn picture. Michael G. Brennan (1839–71) was an Irish painter who worked almost all his life in Capri. Before settling there, however, he drew cartoons for a London journal called *Fun*, and was for a time the rival of another Irish artist, Richard Doyle (1824–83), who created the old cover of *Punch* as well as doing the illustrations for many books. His father, John Doyle, was a political cartoonist; his brother, Henry Edward Doyle, was a religious artist and director of the National Gallery of Ireland after Mulvaney; and two other brothers, Charles (1832–93) and James William Edmund (1822–92), were landscape painters in watercolour. Matthew James Lawless (1837–64) was a brilliant but short-lived artist in oil and watercolour who contributed many illustrations to books and journals, and painted some excellent genre pictures including the fine *Sick Call*. Erskine

Ill. 119

Ill. 120

Ill. 122

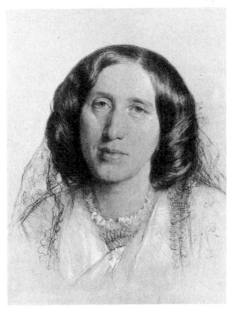

119 SIR FREDERICK WILLIAM BURTON
George Eliot

120 RICHARD DOYLE
Design for a Fairy Tale

Ill. 121 Nicol (1825–1904) was not Irish, but painted a number of subject and narrative pictures on Irish themes, including *Donnybrook Fair* and *The Emigrants*, both in the Tate Gallery. His work is dramatic and well painted, if at times over-theatrical. Nicol was Scottish, and there is a very fine self-portrait drawing in the National Portrait Gallery of Scotland. Alfred Grey and his father Charles (1808–92) were both good landscape artists, the father painting portraits as well, and the son animals, for which he had a rare gift.

In portrait painting, at the semi-official level which the period required, the second half of the nineteenth century was dominated by Stephen Catterson Smith (1806–72) and his son, also named Stephen (1849–1912). The father came to Ireland from Yorkshire to complete some portrait commissions in Londonderry in 1839, subsequently moving to Dublin where he painted with great success for the rest of

121 ERSKINE NICOL
The Emigrants

122 MATTHEW J. LAWLESS
The Sick Call

his life. He was president of the RHA for two periods during the 1860s. He was a stylish artist, bred in the tradition of Sir Thomas Lawrence, though far less flamboyant. His *Self-Portrait* is a good example of his sympathy for form, texture and character in portraiture.

When Catterson Smith Senior died, his practice was taken over by his son, who was equally industrious, though not so gifted. He lacked his father's sympathy for character, and perhaps made up for this with increasingly massive full-length portraits of eminent Irish men and women. For many years he was secretary of the RHA.

Ills. 123, 124

The period ends with several notable artists who are as diverse in style and vision as the painters who began it. William Newenham Montague Orpen (1878–1931), from a well-to-do County Dublin family, studied art at the Metropolitan School before going on to the Slade, where he was a contemporary of Augustus John. His development is closely parallel to that of John. His early drawings and *Ill. 123* landscapes in oil are light, free, assured and wide-ranging. He was a prolific draughtsman, and a very good one. His nudes, particularly, are drawn with great strength and understanding, and his female portraits are often a good deal more sympathetic than those of men.

From 1917 to 1919 Orpen was an official war artist, and a considerable collection of his drawings in France belong to the Imperial War Museum, London. He was at this stage a portrait

123 SIR WILLIAM ORPEN *The Model*

124 SIR WILLIAM ORPEN *A Bloomsbury Family*

painter of some reputation, and while at times his portraits are rather shallow, he was capable of excellent and sympathetic work, particularly in family and group portraits. His groups of the Vere Foster family and of his parents (in the National Gallery of Ireland) are good examples of this, as well as his *Homage to Manet* in the City of Manchester Art Gallery and *A Bloomsbury Family* which belongs in mood to the school of Conder, Sickert and Rothenstein, with whom *Ill. 124* Orpen had much in common.

He delighted in self-portrait; straightforward as well as theatrical and fanciful examples of these abound, most of them vigorous and effective. He often included himself in portrait groups, reflected in small convex mirrors which are a frequent prop in his paintings. In his portrait drawings his style is close to Augustus John's, and one of the finest of these is a study of George Moore in the National Portrait Gallery. He returned to Ireland in the 1920s, and wrote a sad, bad, but

revealing book called *Stories of Old Ireland and Myself*, in which he regrets the changes in taste and the exclusion of people like himself.

The reaction against Orpen, a natural enough phenomenon given the history of the period, was combined with an equally natural reaction among artists after the First World War against the man who had so completely dominated the art scene in Dublin from 1900 to 1914. His pre-eminence then was a technical one, based on his brilliant draughtsmanship, his range and versatility, his intense professionalism as a painter. And it was these qualities that influenced many younger artists, the best of them being James Sleator, who subsequently became president of the RHA, Leo Whelan (1892–1956), who was the principal painter of portraits in Dublin from 1930 to 1950, Lady Glenavy and Kathleen Fox.

Ill. 125 The career of John Lavery (1856–1941) is similar to Orpen's. He was born in Belfast and trained at art school in Glasgow, where he practised for a while before continuing his studies in London and Paris. He then returned to Scotland, and became one of the 'Glasgow School' of painters, rapidly building up a considerable reputation, particularly in the portrayal of women. Like Orpen he worked as an official war artist, and they were both knighted in 1918.

Sarah Purser (1848–1943) was a central figure in art in Dublin, and a good portrait painter, although some of her finest and most sensitive work was not strictly portraiture, for example, *An Irish Idyll* in the Ulster Museum, and *Le Petit Déjeuner*. Sarah Purser was also active in *Ill. 126* the growth and development of Irish stained glass at the turn of the century. Sarah Celia Harrison (1863–1941) was another woman painter of the period whose portraits are honest and straightforward likenesses close in style to those of Sarah Purser.

Sarah Purser's association with the stained glass movement in Ireland at the beginning of the twentieth century was prompted by Edward Martyn, and her studio, which she ran until her death at the age of ninety-four, was founded in 1903. It was called *An Túr Gloine* (The Tower of Glass). Sarah Purser herself designed stained glass, but the real creative impulse for the movement came from Harry Clarke (1889–1931) and Michael Healy (1873–1941). Clarke was a highly distinctive artist with great individuality of style and vision. His debt to Beardsley is clear, as well as his acute consciousness of the concern with form and colour which characterized art training in Britain in the 1890s. Yet he was independent enough in his vision to be able to take these forces and adapt them to his own medium of stained glass

126 SARAH PURSER
Le Petit Déjeuner

125 SIR JOHN LAVERY
Hazel Lavery

with just the right mixture of tradition and individual talent. Michael
Healy was very different. His vision was essentially a simple one,
unsophisticated, and dependent on environment and people for form
and inspiration in his art. Irish churches and cathedrals throughout the
country bear ample witness to the original craftsmanship of both
men. They were also excellent draughtsmen, Clarke a highly
polished book illustrator, Healy a relaxed and unpretentious
watercolourist whose particular subjects were Dublin figures and
street scenes. Others associated with the movement were Wilhelmina
Margaret Geddes (1888–1955), Ethel Mary Rhind (*d.* 1952) and a
number of living artists, Catherine A. O'Brien, Patrick Pollen,
Hubert V. McGoldrick, Richard King, David, Anne, and Terence
Clarke, and William Dowling.

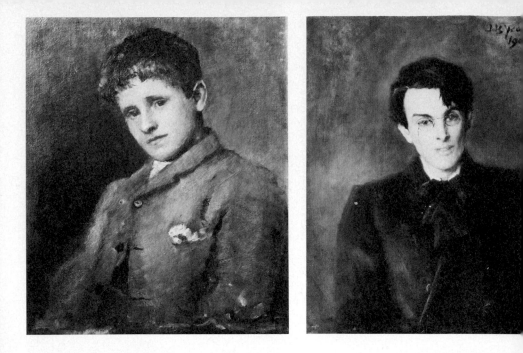

The most sensitive Irish portrait painter of this period, and the man who captured more of the atmosphere of the Irish revival in the vision and determination of the leaders of his own generation whom he *Ills. 127–9* painted, was John Butler Yeats (1839–1922). He started life as an architect, and it was only in 1867, two years after the birth of his elder son, that he took up painting, studying at Heatherleys Art School. It is probable that the early influences on the painter were essentially English, and his technique has much in common with that of George Frederick Watts, in his simpler pieces, and Alfred Stevens. W. B. Yeats has referred to the influence of 'French art', but it seems clear that this was secondary to the prevailing atmosphere of Pre-Raphaelitism, although Yeats soon outstripped these early influences and adopted a direct and individual style which is already assured and *Ill. 127* deeply felt in his portrait of his son, Jack B. Yeats.

During the 1880s Yeats spent periods in London, at his home in Bedford Park, and also in Ireland, and it was not until 1902 that he left the Bedford Park settlement and moved to Ireland and finally to the United States. Bedford Park was a significant experiment in English art and architecture during the last twenty-five years of the nineteenth century, and the contribution made by the elder Yeats was

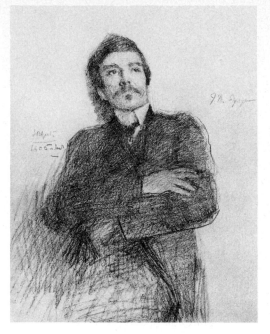

127 JOHN BUTLER YEATS
Jack B. Yeats as a Boy

128 JOHN BUTLER YEATS
William Butler Yeats

129 JOHN BUTLER YEATS
John Millington Synge

considerable. Unfortunately, one's knowledge of his work during this period is severely limited by the fact that the great majority of his paintings from the early years were destroyed by bombing during the Second World War.

His finest period of portrait painting commenced with his return to Dublin in 1902, and during the next few years he produced a series of great Irishmen as well as friends and relations. The immediate contact these works make is invariably through the eyes of the subject. Yeats was able to capture the essence of his sitter's character almost always in the eyes alone, and to add then the gesture, posture and facial bone structure and detail in a loose and impressionistic style which rarely faltered. The paintings of this period were accompanied by many drawings, some of them – for example, that of J. M. Synge – quite *Ill. 129* superb. And Yeats continued to work with the same assurance right up to his death, completing in 1920, for example, the fine self-portrait in the National Portrait Gallery. It is perhaps appropriate to mention John Butler Yeats's portrait of his other son, William Butler Yeats, *Ill. 128* done during the Bedford Park phase, and one of the few portraits of the poet to treat him as a man, and to invest him with human and lovable qualities, youthful, thoughtful and sensitive.

133

Jack Yeats and the moderns

Ills. 130–6 In 1897 Jack B. Yeats (1871–1957) was living in Devon. He was twenty-six years old, and painting some of his most glorious watercolours. They are mostly scenes at fairs, race meetings, boxing booths and inns. Some of them are filled with bright, golden sunshine, *Ill. 131* such as *Waiting*, in which the colour, technique and composition reveal the artist's mastery of this particular medium. But not all of them are as light or sunny. In *His Thoughts to Himself* Yeats shows a rather more solemn aspect of his environment. The drawing is of an isolated figure on a bench in a bar, an empty glass beside him, his solemn face and clasped hands indicative of unsociable detachment. As a drawing it is not half as good as *Waiting*, which is among Yeats's finest watercolours. But as a picture it probably has more to tell us of Yeats's vision, and of his sense of responsibility as an artist, and in a strange way the title can be applied as easily to Yeats as to his subject.

Jack B. Yeats is something of an enigma and will always remain so. He did not believe that knowledge about him, his ideas, his beliefs, the early influence on his art, was important. 'A picture does not need translation,' he once said. 'A creative work happens. It does not need documentary evidence, dates, photographs of the artist, or what he says about his pictures. It doesn't matter who or what I am. People may think what they will of the pictures.' Yet, true as this may be of a painting here and a drawing there, when the whole body of his work is considered, to the extent this is possible, knowledge of the man and artist is bound to enrich understanding of his stylistic development and the expanding range and depth of his vision.

At the time of his visit to Devon, Yeats had spent only eight of his twenty-six years in Ireland. He was born in London only four years after his father's decision to become an artist, and his early years must have been spent in the highly charged atmosphere of his father starting out in a new profession. Between the ages of eight and sixteen he was in Sligo, but in 1888 he was back at art school in London, and he did not finally settle in Ireland until about 1900. At this stage he was a mature and accomplished artist, of great range, versatility and depth of perception and understanding, and the creator of such fine

drawings and watercolours as the *Pastimes of the Londoners* series, the
Devonshire watercolours already referred to, the Norfolk Broads
series, his circus, boxing, betting and racing drawings, and a number
of those almost apocalyptic figures which were to become such an
important element in his work – *The Canvas Man, The Hard Stuff,
The Tinker, The Circus Clown, The Rake* and *Man from Arranmore*. *Ill. 130*

It is difficult to pin down the early influences. Mark Glazebrook has
already pointed out the debt to Degas, although this may well be
indirect. Probably the most profound influence came from the rich
and mostly anonymous graphic illustration which was so essential a part
of journalism during the period in which Yeats grew up, and which
provided him with his first job as an artist when he did drawings for
The Vegetarian in 1888. He subsequently did drawings for the *Daily
Graphic* and the *Manchester Guardian*, as well as a considerable amount
of book and broadsheet illustration at a slightly later stage. He learnt
two distinct things from this 'reportage': the importance of strength
and simplicity of line and composition, and the crucial importance of
depicting in all these drawings 'an event'. It is fair to say that in the
greater part of all Yeats's art, drawings, watercolours, and oils of all
periods, one common distinction may be observed: that of
'something happening'. From *Boat Race Day – Two Bargees Dancing an* *Ill. 134*
Imitation of the Sisters of the Halls through *Riverside Long Ago* to *About* *Ill. 135*

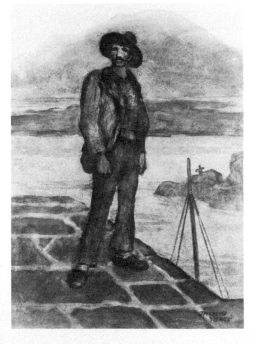

130 JACK B. YEATS
The Man from Arranmore

135

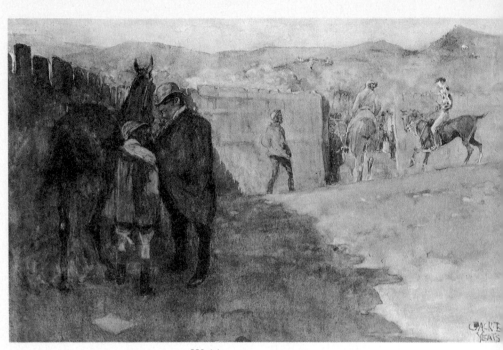

131 JACK B. YEATS *Waiting*

Ills. 1, 136 to *Write a Letter* and *The Two Travellers* his work is distinguished by its emphasis upon actions, encounters, moments of decision, moments of truth. And if one adds to this Yeats's isolated and solitary figures, his men of the west determined to conquer, his boxers determined to defeat their opponents, his jockeys determined to win, his clowns determined to captivate their audiences, then to a very great extent the universal nature of his art may be seen in terms of the individual's encounters with the world, whether the 'world' is an opponent in a boxing ring, or 'the unknown', towards which *The Face in Shadow* is turning. And this universality is common from the early graphics, however specific their location may be, right through his watercolours, his early oils, the richly diverse range of middle period pictures, into the enigmatic landscape of his last period. The breaking down of Yeats's art into periods is only of minor importance in understanding his work. It reveals his technical development, and the points at which he reached the limits of one medium, or of one particular way of looking at his subject. But his imagination and his vision of life, while they grow richer, more varied and more *Ill. 134* profound, do not really change. He is a great draughtsman in *Boat Race*

132 JACK B. YEATS *Empty Creels*

133 JACK B. YEATS *Many Ferries*

134 JACK B. YEATS *Boat Race Day –*
Two Bargees Dancing an Imitation of the Sisters of the Halls

135 JACK B. YEATS *Riverside Long Ago*

Day. He is a great watercolourist in *Waiting*. He is a great painter in *Empty Creels*. He is a great and wonderful artist in *About to Write a Letter*.

Ill. 131
Ill. 132
Ill. 1

His genius tends to isolate Yeats in Irish art. *His Thoughts to Himself* describes effectively his relationship to other painters. While he worked all his mature life in Ireland, exhibiting with the RHA, the Living Art, and in one-man shows, as well as being represented in English and American exhibitions, including the famous Armory show in 1913, Yeats, both as painter and person, kept himself to himself, suffered no fools gladly, took no pupils, was never seen at work, and, as already pointed out, considered that one thing only mattered about himself – the paintings which he produced.

Yeats was an established artist who knew where he was going well before the political eruptions which led to the creation of an independent Ireland in 1921. When he wished to, as in *Bachelor's Walk, In Memory*, he could absorb comfortably the strong vibrations of Irish history and of the emergence of a new State. For the artists who came after him things were not as easy, and in the work of many Irish painters of the '20s and '30s there is often an uncomfortable feeling of strain, a self-consciousness about what 'being Irish' meant. Evidence of it can be found in painters like Sean Keating, Paul Henry, Ills. 137, 142

136 JACK B. YEATS *The Two Travellers*

137 PAUL HENRY *Dawn, Killary Bay*

Ills. 138,
141, 143 George Russell, Maurice MacGonigal, Charles Lamb, Patrick Tuohy,
Christopher Campbell, William Conor, Sean O'Sullivan, all of
whom belong broadly to that school of Irish academic realism,
principally centred on the landscape tradition, which dominated the
period between the wars. This self-consciousness is even present, to
some extent, in the work of the leaders of Ireland's modern
Ills. 144, 145 movement in the '30s, Mainie Jellett and Evie Hone, and continues to
be significant after the Second World War.

For various reasons the best-known Irish artist of the period
between the wars was Paul Henry (1876–1958). He was born in
Northern Ireland, studied art in Paris at Whistler's studio, and settled
in Connemara almost on impulse. His landscapes reveal a superb
Ill. 137 understanding of Irish light, as in *Dawn, Killary Bay*, and a
remarkable subtlety in his treatment of the strange and unusual
combinations of colour in his many paintings of lakes and bogland in

Connemara and Donegal. Many of these have an extreme simplicity, just the careful composition of water and headlands, of turf-stacks against the grey-blue hills along the horizon, and of billowing clouds banked up above his low horizon-line. Occasionally he could introduce figures with great effect, as in the powerful picture, *The Turf-Carriers*, with its echo of van Gogh. Paul Henry's wife, Grace (1868–1953), was also an artist of considerable ability, although her landscapes are on a more domestic scale, lacking the sense of enormous and deserted land and sky. She also did portraits; one of her husband is in the Ulster Museum. A landscape artist who worked in a style quite close to that of Henry was James Humbert Craig (1878–1944). Again, he is more limited. While the technique of a painting like his *Going to Mass* in the Municipal Gallery in Cork is of a high order, the conception of the picture, the event and the landscape in which it is taking place, are rather subdued. *Tholla Bhistrie* in the same gallery is a good example of his work, while in *Cloud Shadows, Connemara* he *Ill. 139* comes close to the strong simplicity of Henry's work. George Russell *Ill. 138*

138 GEORGE RUSSELL ('AE') *The Potato Gatherers*

139 JAMES HUMBERT CRAIG *Cloud Shadows, Connemara*

(1867–1935) painted many good and simple landscapes, but was led by his highly individual imagination into a kind of fairytale world which he depicted with great charm but insufficient strength to resist an insipid quality in many of his works. At his best, as in *The Potato Gatherers*, he could display great strength of composition and colour, and *The Gully*, in the Municipal Gallery of Modern Art in Dublin, is a fine example of his more typical 'soft' work. Letitia Hamilton (1878– 1964) was a landscape painter of the same period who may be said to have combined the palette of Paul Henry with the impressionistic style and impasto of Roderic O'Conor. At her best her paintings are rich in colour and well composed. Her sister, Eva H. Hamilton, also painted competent landscapes in oil. William Conor (1884–1968) conveys very well in his oils and drawings the atmosphere in

Ill. 138

Ills. 109–11

Northern Ireland, concentrating to a considerable extent on urban scenes, as in *The Jaunting Car*.

One of the finest artists of this generation of painters, W.J. Leech (1881–1968), was born and educated in Dublin and studied art at the Metropolitan School of Art under Walter Osborne before going to Paris and the Académie Julienne. His first picture at the RHA was in 1899, and he was a full member by 1910. Even so, the freshness and simplicity of his technique places him in an influential position in Irish painting at a much later stage. His *Convent Garden, Brittany* is typical of his early experimentation with light and with a rich and thick application of paint in the manner of the *pointillistes*.

Ill. 140

Mary Swanzy (*b.* 1882) has a landscape style not unlike Leech's, although her technique seems generally stronger and more decisive than his, with harder colours. Maurice MacGonigal (*b.* 1900), the president of the RHA, is a good landscape artist, painting with rather muted colours soft, blue-grey scenes at country fairs, and occasionally quite vivid interiors. Frank McKelvey (1895–1975) is another landscape artist whose muted and soft colours suit the misty and rain-swept countryside which is generally the subject of his paintings. Charles McAuley and Maurice Wilks are two other Northern Ireland landscape artists, as well as Robertson H. Craig (*b.* 1916).

140 W. J. LEECH
*Convent Garden,
Brittany*

143

141 PATRICK TUOHY
A Mayo Peasant Boy

142 SEAN KEATING
An Aran Fisherman and his Wife

143 CHARLES LAMB
The Quaint Couple

A group of subject and narrative painters, in style quite close to the more conventional landscape artists of the period between the First and Second World Wars, produced four figures of note: Sean Keating (*b.* 1889), Patrick Tuohy (1894–1930), Charles Lamb (1893–1964) and Christopher Campbell (1908–72). Keating, a former PRHA, is an excellent draughtsman, and his oil paintings, with their solid sense of mass and volume, have considerable strength. They evoke the romantic stoicism of the western seaboard, the rural Ireland of Synge and O'Sullivan. Charles Lamb is more diverse, tackling landscape as well as the portraits of types, like his Lough Neagh fisherman or *The Quaint Couple* in the Cork Municipal Gallery. Lamb is less florid in style, and less theatrical. Patrick Tuohy is a portrait and figure painter of great feeling whose work is seen at its best in *A Mayo Peasant Boy.* Christopher Campbell was a Dublin painter, introverted and tense, self-conscious, but rich and powerful

Ills. 141–3

Ill. 143

Ill. 141

in both the technical ability and the vision of his art. He was an excellent draughtsman. Other portrait painters working at this time were Estella Solomons (1882–1968), Sean O'Sullivan (1906–64) and Lilian L. Davidson (*d.* 1954).

Ill. 145
Ill. 144
Mainie Jellett (1896–1943) and Evie Hone (1894–1955) are the great innovators in modern Irish painting. Mainie Jellett studied art in Dublin before going to London where she worked under Walter Sickert. She then moved to André Lhote's studio in Paris, and worked there for a time on cubist theories, though modified to suit representational painting. This did not satisfy her desire to reach at least some of the fundamental truths about her art before choosing her own area of self-expression. Lhote compromised cubist theories by adapting them to landscape, and while Mainie Jellett was conscious that she might well do the same, she first wanted to explore 'the extreme forms of non-representational art'. In 1921 she and Evie Hone, with whom she had studied under Lhote, persuaded Albert Gleizes, a *cubiste intégral*, to accept them as his pupils and to teach them the fundamentals of cubist theory. For ten years they alternated between periods of study in Paris with Gleizes and teaching and painting in Dublin.

Mainie Jellett worked out these lessons of a decade in austere abstract art of a very high order. Her dependence on form and colour led her to a profound understanding of the range and intensity of pure abstract based on the almost limitless permutation of her essentially simple material. Many of her abstracts are built up from a central 'eye' or 'heart' in arcs of colour, held up and together by the rhythm of line and shape, and given depth and intensity – a sense of abstract perspective – by the basic understanding of light and colour. It was natural for many of her abstract ideas to assume a Christian connotation, and she herself regarded as most important her 'non-representational work based on Christian religious subjects treated symbolically without realism'. In recent years much of her early work, when she was studying under Walter Sickert and then André Lhote, has come to light. It greatly enhances her stature, and reveals a sensibility and a strength of vision which places her in a unique position in modern Irish painting, as innovator, as influence, and as a leader in the development of ideas. More than any other painter she made known in Ireland all the challenges and opportunities which are associated with the twentieth century's greatest art movement – Cubism.

Evie Hone belonged to the same family ancestry as the other Irish artists of the same name, and was a direct descendant of Joseph Hone, a brother of Nathaniel Hone the elder. Her development and training closely followed that of Mainie Jellett. She studied under Sickert, Bernard Meninsky and also Glen Byam Shaw, before moving to Paris and working under André Lhote and Gleizes. She and Mainie Jellett held a joint exhibition in Dublin in 1924, but her development took her away from painting into stained glass. She joined *An Túr Gloine* in about 1932, and with the help of Michael Healy established herself as one of the leading stained glass artists of the twentieth century. Perhaps her finest work is the great Eton College window. *Ill. 145*

It was natural that the ideas of these two artists should have been profoundly influential in the Dublin of the 1930s, through both their work and their teaching. In 1943 Mainie Jellett founded the Irish Exhibition of Living Art, with Evie Hone, Louis le Brocquy, Norah McGuinness and Jack Hanlon among its founder members. It was born out of a justified frustration at the reactionary course pursued by the RHA and a feeling among its founder members that an annual show was needed where the paintings would matter more than the autocratic hierarchy of membership. If it re-established the plurality of groups of artists this was a necessary price to pay for the emergence of important painters, like Louis le Brocquy, whose work at that time *Ills. 146–9* was being rejected by the RHA.

144 MAINIE JELLETT
Abstract

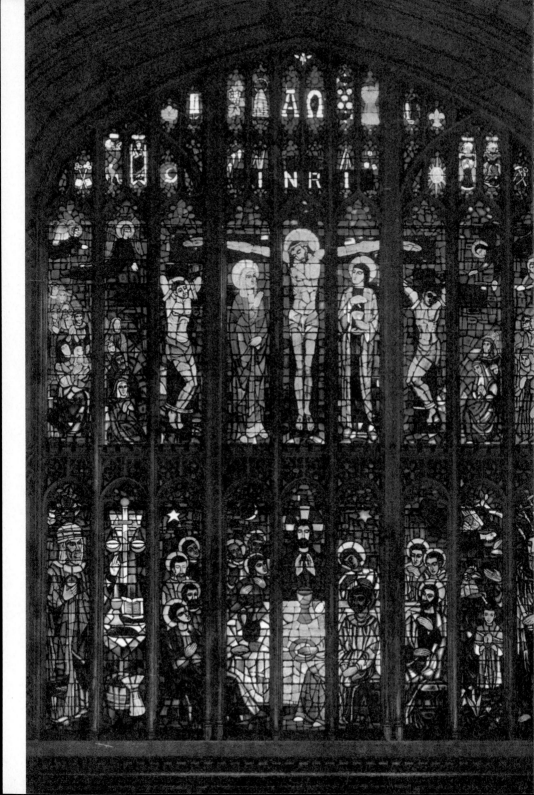

Louis le Brocquy (*b.* 1916) is a singular artist with a highly individual vision. He was largely self-taught, studying in France and Spain, and in Venice, and starting to paint in about 1939. His early work shows the influence of Manet and Degas, and is followed by a period when he was painting in a cubist style and developing themes of isolation, in terms of both tinkers (the isolation of an alien group in the community) and prisoners. This period culminated in paintings based on the theme of the family, children and of communication. The paintings of this period are closely related to le Brocquy's work as a designer of tapestry, and between the late '40s and the mid-'50s he produced a number of fine works in this medium which closely parallel his oils during the same years. The influence of Lurçat is apparent in le Brocquy's *Garlanded Goat*, which is based on a painting, *Goat in Snow*, in the Leeds City Art Gallery.

Ills. 146–9

Ill. 146

During 1956 a notable change occurred in le Brocquy's style. Having reached a point of understanding with the family as the central focus, the artist returned to the even more crucial problem of the existence and meaning of the individual being. From 1956 onwards, in what has been called his 'White Period', le Brocquy has been exploring the emergence of the human being as a physical and psychological form. His *Isolated Being* sums up the highly tentative nature of any artist's attempt to capture the total essence of human personality. It rejects the straightforward physical appearance of one

Ill. 147

145 EVIE HONE Chapel window, Eton College

146 LOUIS LE BROCQUY
Garlanded Goat

147 LOUIS LE BROCQUY
Isolated Being

148 LOUIS LE BROCQUY
Caroline

human being as exclusive of any universal idea of humanity. In this respect it is important that le Brocquy has consistently avoided portrait painting, in spite of an early competence, and the fact that the human form has always been the basic subject of his work. A great deal of the impulse behind this approach is revealed by *Caroline*, a painting of a mongoloid child done by le Brocquy in 1956. In it the unformed and devoted face of the child, with its mixed expression of trust and lack of comprehension, implies a fluid and flexible concept of personality, and a sense of communication which is at best very fragile and slight.

Ill. 148

150

In his later work, represented by *Study for Reconstructed Head of* *Ill. 149*
S.B., le Brocquy is applying the same restrained mixture of physical
and psychological representation to public rather than private figures,
in this case Samuel Beckett. Not unnaturally the dangers of such an
approach are greatly increased by the physical familiarity of the
subject, and the fact that the temptation to allow this aspect to
predominate can be countered only by the extremely difficult
problem of transforming psychological impressions into visual terms.
The greatness of this picture lies in the way le Brocquy has captured
the essence of Beckett's own complicated and obscure art in the
haunted, emergent face, and the grey-flecked, whitish mist from
which it seems to appear.

Patrick Scott (*b.* 1921) started as an architect, and his earliest *Ill. 150*
paintings have a clear, strong, formal composition. He passed
through a phase of very simple, almost child-like landscapes in the
mid-'40s, with the elementary, horizon-line division of his canvases,

149 LOUIS LE BROCQUY *Study for Reconstructed Head of S.B.*

but beyond this there is no real concern with perspective. The flat, almost diagrammatic, birds, animals and fish which form part of these early compositions are isolated from one another across the canvas in a formal pattern. In *The Sun*, painted in 1944, he made his first venture into a thematic form of composition which has been central to his art since then. The painting is of fields and sky with a massive sun low over the horizon. For the past twenty years Scott has worked mainly on this theme of extremely simple landscapes, with ever-increasing subtlety of colour, and economy of formal construction.

Ill. 151 Norah McGuinness (*b.* 1903), another pupil of André Lhote, was born in Londonderry, and for some years worked in Paris, London

and New York before settling in Dublin. Her landscapes are bold and strong in colour and composition, with hard, angular lines, and strong greys, browns and blues. In her latest work there is a softening of line and texture, but her most typical style is to be seen in paintings like *Morning Moon* in the Irish Arts Council collection, or *Tide Receding, Dublin Docks*. Nano Reid (*b.* 1905) held her first exhibition in Dublin in 1933, after studying art in that city and in Paris. From the beginning she was good at drawing, and her flexible and fluid sense of line is apparent in her oils. The colours in her paintings are muted, almost flat, and her first concern is in composition, line and movement, rather than the play of light. This takes away from her paintings some of the depth and perspective, but gives them a kind of woven texture, rich in allusion. Her subjects are domestic and immediate, and her treatment simple.

Ill. 151
Ill. 152

In his earlier work Gerard Dillon (1916–71) has this same tapestry-like quality, and his many experiments with different media and

Ill. 153

150 PATRICK SCOTT
Yellow Device

151 NORAH MCGUINNESS *Tide Receding, Dublin Docks*

152 NANO REID *Cats in the Kitchen*

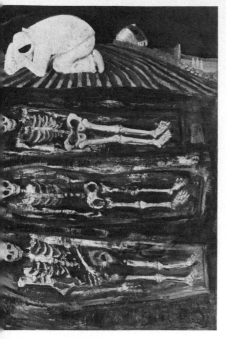

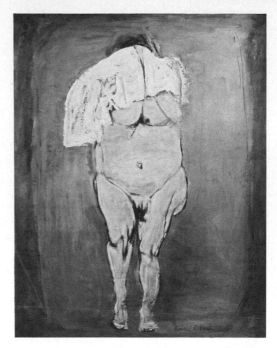

153 GERARD DILLON
The Brothers

154 PATRICK COLLINS
Nude

varied textures indicate a dissatisfaction with the clear and lucent
quality of oil paint. But his best work is direct, and his use of simple
but fundamental themes, such as that connecting the clown with
death, has produced some excellent and powerful paintings like *The
Brothers*, with its poignant and personal statement on the theme of
man's mortality. Patrick Collins (*b.* 1910) has an enclosed and
introverted vision, and a sombre range of colour. His fluency in the
treatment of nudes is not matched by his landscapes, which only
rarely capture the luminous and expansive light of Sligo, Wicklow or
Donegal. But some of his nudes are fine paintings, with great softness
and strength.

 Anne Yeats (*b.* 1919), the niece of Jack B. Yeats, is a concise
landscape and still-life artist, with an excellent sense of life, and a
growing richness of form and colour in her work. Father Jack Hanlon
(1913–68) shows the influence of André Lhote in his colour and
composition. He is an excellent watercolourist and a good painter in
oils, whose simple and domestic subjects have a cleanness and
brilliance of colour as well as strong composition. In *The Protestant*

Ill. 153
Ill. 154

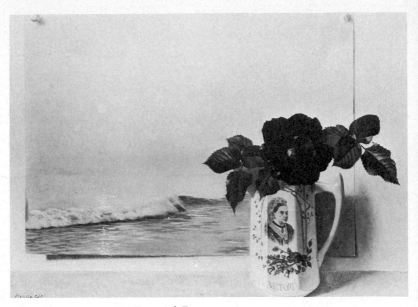

155 PATRICK HENNESSY *Imperial Rose*

and the Catholic Garden his use of white betrays his first allegiance to watercolour, but the painting has strong tonal patterns and excellent balance. A strong independence of style also characterizes the work of Harry Kernoff (1900–74), most of which concentrates on Dublin scenes and characters. Muriel Brandt is rather more formal in style, but consistently competent in portraiture, and in graphic work.

Two artists who have, to some degree, bridged the gap between the Living Art and the RHA are George Campbell (*b.* 1917) and

Ill. 155 Patrick Hennessy (*b.* 1915). Campbell has always been a good and active draughtsman, with the result that his work achieves an outstandingly clear and decisive linear style in his early landscapes and west of Ireland village and harbour scenes. He combined this with a good understanding of light and the use of soft greys and blues. Later he visited Spain, and the strong, hard light affected his style and use of colour. In his later work the hardness of line has been replaced by hardness of colour; this has tended to make his work rather cold, and somewhat academic in its appeal.

Patrick Hennessy is an artist with immense technical virtuosity in an age when visionaries and innovators predominate. This has obscured the highly individual nature of his work. He has a surrealist vision, and his paintings of still-life subjects, of apples and roses, of

156

156 DEREK HILL *Tory Island from Tor More*

dream-like landscapes and exquisite *trompe l'œil*, have a rich
substratum of meaning connected with time, decay and death.
Imperial Rose is an excellent example of the way Hennessy paints on *Ill. 155*
two quite different levels.

Derek Hill (*b.* 1916) is an English artist settled in Ireland whose
finest landscapes belong to the wild and stormy Donegal coast near
which he lives. He has steered an uneasy course between professional
portrait painting, for which he has great sympathy and feeling, and
the more intractable material of landscape art, for which he has
greater affection. His *Tory Island from Tor More* is a magnificent open *Ill. 156*
seascape, with simple, controlled composition, and the brilliant, silver
flash of hard light over grey seas.

One of Derek Hill's pupils, if the term is not too inappropriate, is
the Tory Island primitive, James Dixon (1887–1970). Dixon watched *Ill. 157*
Hill paint, and said he could do better. He was given the materials,
and embarked on a rich and uninterrupted career as painter of
seascapes and landscapes, mostly containing the events – such as the
capture of muldoons, the firing of rockets, the landing of helicopters –
which break the monotony of island life for the people off this remote
north-west coast of Ireland. But some of his paintings are merely of
storms, and in their strength and colour they capture precisely the

almost terrifying greyness and wildness of the islands on the Atlantic seaboard.

William Scott (*b.* 1913) is of Irish-Scottish parentage and was trained in Belfast before going on to the Royal Academy Schools in London. He is an abstract painter whose evolution has followed the 'inner principle' theory, after quite extensive periods as a still-life artist. His early paintings have great simplicity of composition, and *Ill. 158* reveal a great deal about his later work. *Still Life* belongs to the late '50s. He had already at that stage been painting in abstract, and had returned to the domestic still-life subjects for a period before again taking up the form and colour compositions of the '60s. The pots and pans which make up his picture have been reduced almost to flat shapes, spaced from each other and related in terms of outline and position as well as colour.

157 JAMES DIXON
Tory Island

158–9 WILLIAM SCOTT
Still Life and,
below, *Direction*

Seen in relation to *Still Life*, Scott's *Direction*, painted some ten *Ills. 158, 159*
years later, assumes much greater abstract significance in its
relationship of form and colour, and the rhythm which derives from
the tensions created by this relationship.

As well as William Scott, Northern Ireland has produced a number
of fine modern painters, partly as a result of the more enlightened and
objective tradition of art-training established in Belfast during the late
'30s and '40s. John Luke (1906–75) was an early leader in technical
innovation, and in the extreme simplification of landscape into clean

160 COLIN MIDDLETON *The Skylark*

Ill. 160
Ills. 161, 164–5
Ills. 162, 163

line and flat, luminous colour. Lady Mabel Annesley applied modernist theories to watercolour painting and wood engraving, at which she showed considerable artistic capability. But the main figures in Northern Ireland of the '40s and '50s have been Colin Middleton, Dan O'Neill, Basil Blackshaw, and of a slightly later generation, Arthur Armstrong, T.P. Flanagan, Noreen Rice and Deborah Brown.

Colin Middleton (*b.* 1910) has continued to experiment with style and technique throughout his development as a painter. There have been periods of surrealism, of cubist style, of extreme romanticism in which the influence of Yeats was strong, and periods when the ascetic line and form of Ben Nicholson affected his work. It has been said of Colin Middleton's notebooks that they offer 'evidence of an unsatisfied pilgrimage through the devious ways of modernism'. But if Middleton's work displays such uncertainty, and it is a justified reflection of contemporary trends in art, the reflection is conveyed in work which, in each 'period', displays great technical ability and a profound understanding of the unchanging material which forms the

.inspiration for his art. Perhaps his most sensitive work was done during the '40s and early '50s, to which period *The Skylark* belongs. *Ill. 160*

Dan O'Neill (1920–74), born in Belfast, is the complete opposite of Middleton: consistent in style, constrained in his colour range, and profound in his statements on a fairly narrow area of human activity, although he is also the painter of many splendid landscapes, including *Knockalla Hills, Donegal* in the Ulster Museum, *Glendalough under* *Ill. 161* *Snow* in the Herbert Art Gallery in Coventry and *Clay Pit* in the Cork Municipal Gallery. *Mother and Child* is typical of his fine and original *Ill. 164* treatment of the most simple of themes.

Terence P. Flanagan (*b.* 1929) has continually simplified his concept of landscape, and his latest work in this category relies almost entirely on the horizontal patterns of light to give depth and perspective to his work. His earlier painting, of which *On the Terrace* *Ill. 163* is a good example, relied on stronger composition with rather more subtle treatment of colour and tone.

Arthur Armstrong (*b.* 1924) has a very different approach to *Ill. 162* landscape, building up perspective in terms of line and a strong and varied use of colour. In his oils his paint is thick, and has a kind of

161 DAN O'NEILL *Knockalla Hills, Donegal*

163 TERENCE P. FLANAGAN *On the Terrace*

162 ARTHUR ARMSTRONG
Rocks and Sea near Roundstone

164 DAN O'NEILL *Mother and Child*

165 BASIL BLACKSHAW *The Field*

pitted texture. The colours are rather muted, quite different from the strong and varied shades in his drawings.

Basil Blackshaw (*b.* 1932) paints landscapes and portraits. His portraits have an aggressive appearance, loaded with meaning and statement of an almost antagonistic type, which nevertheless, in their harsh honesty, have value. His landscapes are strong in colour and sense of space, with good light and excellent perspective. *Ill. 165*

Deborah Brown's work is almost entirely abstract, and both she and Noreen Rice frequently use collage techniques. The work of the former is pure abstract, concerned with the balance and inter-relationship of colour and form. Noreen Rice, on the other hand, is a symbolist artist, employing realist subject-matter, but in a fragmented way.

One other Northern Ireland artist of great importance is the sculptor, F. E. McWilliam (*b.* 1909). He was born in Banbridge, County Down, and studied in Belfast and at the Slade School in London before going to Paris. He was represented in the Herbert Art Gallery exhibition entitled 'Metamorphosis', based on the twentieth- *Ills. 166, 167*

Daniel O'Connell

166 F. E. MCWILLIAM
Man and Wife

167 F. E. MCWILLIAM
Elizabeth Frink

century concern with the transfer in art from representational to abstract. This idea is central to McWilliam's work. As late as 1956 he made his completely representational *Elizabeth Frink*, yet much earlier he was experimenting with the breakdown of human form, as in *Man and Wife*, and in a considerable portion of his work this has been carried through into total abstract.

Ill. 167

Ill. 166

The tradition of sculpture in Ireland during the nineteenth century had been strong, and at the beginning of the twentieth it received new inspiration from the work of several fine sculptors in Dublin, Oliver Sheppard (1864–1941), John Hughes (1865–1941), Andrew O'Connor (1874–1941), Albert Power (1883–1945) and Jerome Connor (1876–1943). Sheppard's work has much of the turn-of-the-century, *art nouveau* inspiration in it. Albert Power's style and force are largely influenced by Rodin, and Rodin was also one of the principal formative influences on Andrew O'Connor, whose fine statue of Daniel O'Connell in the National Bank in Dame Street has been a seminal work in the development of sculpture in Ireland. Among modern sculptors the work of Oisin Kelly has a strong and vibrant quality, with many medieval echoes in the religious pieces, and a fine sense of lightness and comedy in such examples as *Teazle*. His metal *Cross* is a typical work. Seamus Murphy, the Cork sculptor (*b.* 1907), has maintained a tradition of portraiture, as well as

Ill. 168

Ill. 169

169 OISIN KELLY
Cross

producing religious work; and among the younger artists Ian Stuart has established an individual style in abstract work, while Edward Delaney has pursued the more conventional tradition of representational sculpture.

But the two most significant sculptors are both women, Hilary Heron (*b.* 1923) and Gerda Fromel (1931–75). Much of Hilary Heron's early work was carved in wood. It has a strength and simplicity which derive from its return to fundamentals of technique and expression, exemplified in her supine figure, *And the Lord God formed Man from the Dust of the Ground*. In her work she has great spatial awareness, and a tension which derives from this. This becomes even more apparent in her relief work, some of her carved *Ill. 170* panels, such as the *Christus Rex*, and in *Crazy Jane*. Gerda Fromel settled in Ireland in 1956 after studying art and sculpture in Germany. Her work in some ways parallels that of McWilliam, particularly in

170 HILARY HERON
Crazy Jane

171 GERDA FROMEL
Tree

172 EDWARD MCGUIRE
*Portrait of
Seamus Heaney*

the attempt at metamorphosis of representational concepts into abstract realizations. She used marble for sculptured landscapes, employing the colours and veins and texture, but with only the most tentative presentation of horizon and sun. Her *Tree* is a good example *Ill. 171* of her transitional work from realism to abstract. She died in tragic circumstances in 1975.

The range and diversity of the work of artists active in Ireland in the period since 1960 is immense. It extends from the brilliant academic portraits and still-life paintings of Edward McGuire, with *Ill. 172* their aura of surrealism, to the conceptual work of artists like James Coleman. No list could hope to be adequate or complete, no emphasis or judgment to hold permanent validity.

Certain groups and individual painters should be mentioned. The academic tradition has been sustained well by James le Jeune, Desmond Carrick (*b.* 1930), Thomas Ryan (*b.* 1929) and David

174 PATRICK PYE *The Mocking of Christ 3*

Hone. The modern movement has been effectively led and diversified by artists like Micheal Farrell (*b.* 1940), Brian King (*b.* 1942), Roy Johnston (*b.* 1936), Theo McNab (*b.* 1940), Robert Ballagh (*b.* 1943), Clifford Rainey (*b.* 1948), Tim Goulding (*b.* 1945) and Martin Gale (*b.* 1949). There is also an immigrant school of artists influential *Ill. 173* in Ireland during the period, and including Alexandra Weijchert, Erik Adriaan van der Grijn (*b.* 1941), Adrian Hall (*b.* 1943) and Colin Harrison (*b.* 1939).

Cecil King is a somewhat older painter who came late to his art, but struck out in an abstract direction with highly finished pastels and undisciplined oils. The form of his line and the soft textures of his colour have produced some excellent work in the medium of pastel. Patrick Pye (*b.* 1929) also works in pastel, as well as in oil and stained *Ill. 174* glass. Much of his early painting was severely muted in colour, depending on compositional form and balance for its effect, and mainly religious in theme. The inspiration for much of his early work came from the Italian primitives, and his understanding of colour

169

173 MARTIN GALE *Artichoke Window*

175 BARRIE COOKE
Siobhan McKenna

Ill. 144 from Mainie Jellett's work. More recently his palette has become greatly enriched, almost adding a new dimension to his work. Anne Madden (*b.* 1932), the wife of Louis le Brocquy, is severely abstract, although much of her inspiration comes directly from colour and tone in landscape. It is represented, however, in a highly fluid, though hard-edge, manner. She is also a sculptor.

Ill. 175 Barrie Cooke (*b.* 1931) settled in Ireland in the mid-'50s, in County Clare, and painted landscapes, as well as some excellent nudes and studies of birds and animals. His line is always loose and fluid, both in his drawings and in his oils, and he depends to a large extent on the subtle effects to be derived from tonal values. This applies equally to his nudes and his landscapes. His early work suited the wild and barren areas of Ireland around County Clare. Subsequently he moved to Kilkenny, and the far richer landscape there struck chords of his early life in Cheshire, where he was born, and produced a series of far richer landscapes, with strong greens and yellows. His portrait and figure studies, however, have a greater richness and depth.

Ill. 176 Micheal Farrell is a leading figure among young Irish painters who came to prominence in the mid-'60s. For his often monumental hard-edge paintings he employs Celtic motifs, although the simplified and

fundamental nature of his abstract art deprives it of specific statement on the motif level, just as the balanced patterns and colours carry the abstraction beyond the severe rhythms of the artist like William Scott. Among younger artists who should be mentioned are Tim Goulding, Brian King, Martin Gale, Donal O'Sullivan, Robert Ballagh, Vincent Browne, Roy Johnston and John Kelly. Mention should also be made of Brian Ferran (*b.* 1940), Charles Harper (*b.* 1943), Brian Henderson (*b.* 1950), John Devlin (*b.* 1950), John Byrne (*b.* 1945) and John Burke (*b.* 1946).

A number of figures working in Dublin at present fit into no clear grouping of artists. Among these is Patrick Hickey (*b.* 1927) whose graphic work is among the best being done in Ireland, and whose paintings have grown in style and texture out of graphic processes. In his latest work these oils have included some excellent Wicklow landscapes.

Ill. 177

Pauline Bewick (*b.* 1935) is a stylish and very individual graphic artist, with a particularly colourful and original treatment of animals. She is a descendant of Thomas Bewick.

176 MICHEAL FARRELL *Study I*

177 PATRICK HICKEY *Escarpment, Glendalough*

Finally there are two Irish landscape artists who, in their technical strength and the range of their artistic vision, exemplify the continuing resilience of this, the finest strand in the complex network of Irish art. Brian Bourke (*b.* 1936) is much more than a landscape painter. Indeed, some of his most striking work has been done in the painting of nudes, portraits and self-portraits. But in these areas his view of life is still filled with an element of mockery and disdain. His

Ill. 178 landscapes have a far greater severity and depth. *Winter* is a composite landscape of the artist's school grounds and building, painted partly from memory, and partly as the result of subsequent visits. In colour it is filled with the light of remembered winters, the flat, sombre mauves and blues, and of real winter, plainly observed and accurately depicted. In his foreground there are implications of wider vistas and of the arbitrary nature of choice in the painting of any scene.

This aspect of Bourke's painting is exemplified in his self-portraits, which are numerous and immensely varied. They almost all have a

172

178 BRIAN BOURKE *Winter*

179 CAMILLE SOUTER *And So Came Spring*

hint of self-mockery, and many are intentionally presenting the artist
in an absurd or quite arbitrary light, such as his *Self-portrait, nude, with
Fireman's Helmet.*

Camille Souter (*b.* 1929) is a more restrained artist, less flamboyant
in her approach, more muted in colour, and more consistently a
landscape artist, although her work does also include much still-life,
and periodic interest in action subjects such as circuses. Her earliest
work was abstract as well as representational, and more colourful.
Her later landscapes have become far more significant though
restrained paintings, with excellent perspective, and with a growing
element of subtlety in their conception that adds to their impact.
There is great range of feeling in such pictures as *Bog – Early Morning*
in the Trinity College collection, *The Last of the Radico* in the Ulster
Museum, *And So Came Spring*, and *Just Before the Haymaking* in Sir
Basil Goulding's collection.

Ill. 179

Bibliography

The amount of writing on various aspects of Irish art is very considerable in some periods, negligible in others. No attempt is made here to cover any of the periods or special subjects exhaustively. The books and articles in periodicals listed here are those which have been consulted for the writing of this history, or are considered to be important or unique studies of their subjects.

General Works

Books

ARMSTRONG, Sir Walter. *Art in Great Britain and Ireland.* London, 1909

BELL, S.H., ROBB, Nesca A., HEWITT, J. *The Arts in Ulster.* London, 1951

BENEZIT, E. *Dictionnaire Critique et Documentaire des Peintres, Sculpteurs, Dessinateurs et Graveurs.* Grund, 1960

BRYAN, M. *Dictionary of Painters and Engravers*; first published 1816; revised G.C. Williamson, 1903–4

CAREY, William. *Some Memoirs . . . of the Fine Arts in England and Ireland.* London, 1826

GRANT, Maurice Harold. *A Dictionary of British Sculptors from 13th to 20th century.* London, 1953

GUNNIS, Rupert. *Dictionary of British Sculptors 1660–1851.* London, 1953

IRISH ART HANDBOOK. Dublin, 1943

PILKINGTON, Revd. M. *A Dictionary of Painters.* Editorial additions were made by James Barry and Fuseli, 1798, 1810

REDGRAVE, Samuel and Richard. *A Century of British Painters.* Edited by Ruthven Todd, London, 1947

STRICKLAND, Walter G. *A Descriptive Catalogue of the Pictures, Busts, and Statues in Trinity College, Dublin, and in the Provost's House.* Dublin, 1916

STRICKLAND, Walter G. *A Dictionary of Irish Artists,* 2 vols, London and Dublin, 1913

The Dictionary of National Biography

WALKER, J. Crampton. *Irish Life and Landscape.* Dublin, 1927

(WILLIAMS, John) 'PASQUIN, Anthony'. *An Authentic History of the Professors of Painting, Sculpture and Architecture who have painted in Ireland.* London, 1796

Periodicals, Catalogues, etc.

BODKIN, Thomas. *Report on the Arts in Ireland.* Government Publications Office, Dublin, 1949

COSGRAVE, E. McDowell. *A Catalogue of Engravings of Dublin.* Dublin, 1905

ELMES, Rosalind M. *Catalogue of Engraved Irish Portraits mainly in the Joly Collection and of Original Drawings.* Dublin, n.d.

ELMES, Rosalind M. *Catalogue of Irish Topographical Prints and Original Drawings (National Library of Ireland).* Dublin, 1943

Catalogue of Pictures and Other Works of Art in the National Gallery of Ireland and the National Portrait Gallery. Dublin, 1928

Catalogue: *Irish Houses and Landscapes.* Ulster Museum Exhibition. Belfast, 1963

Catalogue: *Pictures from Irish Houses.* Ulster Museum Exhibition. Belfast, 1961

Illustrated Catalogue: *Municipal Gallery of Modern Art.* Dublin, 1908

McGREEVY, Thomas. *Fifty Years of Irish Painting.* Capuchin Annual, 1949

'The Arts in Ireland'. *Apollo Magazine,* October, 1966. (Special issue on Irish painting, furniture, etc.)

WHITE, James. 'The Visual Arts in Ireland'. *Studies,* Spring, 1955

WHITE, James, and WYNNE, Michael. *Irish Stained Glass.* Dublin, 1963

Celtic Art

DILLON, Myles and CHADWICK, Nora. *The Celtic Realms*. London, 1967

HENRY, Françoise. *Irish Art*, 3 vols, 1965–70. The definitive work on Irish art in the Celtic period.

JACOBSTHAL, P. *Early Celtic Art*. Oxford, 1944

Individual Artists

BARRY, James. *Series of Etchings from his Paintings in the Adelphi*. London, 1808–10

BERNARD, Bayle. *The Life of Samuel Lover, R.H.A., with Selections from his Papers*. London, 1874

BERRY-HILL, Henry and Sidney. *George Chinnery, Artist of the China Coast*. Leigh-on-Sea, 1963

BODKIN, Thomas. *Four Irish Landscape Painters*. London, 1920 (George Barret, James Arthur O'Connor, Walter Osborne, Nathaniel Hone)

BODKIN, Thomas. *Hugh Lane and His Pictures*. Dublin, 1934

CONOR, William. *The Irish Scene*. Belfast, 1944

DAHORNE, J. *Pictures by William Mulready*. London, n.d.

DENSON, Alan. *Thomas Bodkin: a Bio-Bibliographical Survey*. Kendal, 1967

FRYER, E. *The Works of James Barry*. London, 1809

GRIGSON, Geoffrey. 'Some notes on Francis Danby'. *Cornhill Magazine*. London, 1946

LAVERY, Sir John. *The Life of a Painter*. London, 1940

LOVER, Samuel. *Legends and Stories of Ireland*. London, 1831

McGREEVY, Thomas. *Jack B. Yeats*. Dublin, 1945

MULVANEY, T.J. *Life of James Gandon*. London, 1846

O'DRISCOLL, W. Justin. *A Memoir of Daniel Maclise*. London, 1871

ROBERTS, William. *Francis Wheatley, his Life and Works*. London, 1910.

SHAW-SPARROW, Walter. *John Lavery and His Work*. London, n.d.

SHEE, Martin Archer. *Elements of Art*. London, 1805

SHEE, Martin Archer. *Memoir*. London, 1860

SHEE, Martin Archer. *Rhymes on Art*. London, 1809

STEPHENS, Frederick G. *Memorials of William Mulready, R.A.* London, 1890

YEATS, Jack B. *Life in the West of Ireland*. London, 1912

Acknowledgments

We are grateful to the following individuals and institutions for permission to reproduce photographs:
The Earl of Altamont 53, 83; Armagh County Museum 138; Bruce Arnold Esq. 87; Arts Council, Dublin 159, 175; Arts Council/Kildare County Council 173; Bank of Ireland, Dublin 168; Belfast Harbour Commissioners, Belfast 73; Bibliotheque Nationale, Paris 19; Board of Trinity College, Dublin 10, 11, 18, 20–3, 46, 94; Bord Fáilte Éireann 24, 32, 53, 83, 143, 151; Commissioners of Public Works of Ireland 7, 9, 25–8, 36, 76; Major E.A.S. Cosby 52; Cork Municipal Gallery 143; Courtauld Institute of Art, London 15, 33–5, 44; Courtauld Institute of Art, London (Witt Collection) 44; The Dawson Gallery, Dublin 146, 153, 169, 171, 177; Eton College, Windsor 145; Michael Gorman Esq. 88; Sir Basil Goulding 154, 179; Graves Art Gallery, Sheffield 86, 116; Mrs Rosalinda M.F. Green 174; Arthur Guinness Son & Co. (Dublin) Ltd 85; Sean J. Heffernan Esq. 177; Herbert Art Gallery and Museum, Coventry 163, 167; John Hewitt Esq. 160; Derek Hill Esq. 157; Mrs John Hunt 71; Inter-continental Hotels, Dublin 170; The Irish Georgian Society, Leixlip, Co. Kildare 55; Manchester City Art Galleries, Manchester 104; Mr and Mrs Paul Mellon 59; Municipal Gallery of Modern Art, Dublin 108, 109, 125, 132, 139, 141, 142, 147, 152, 173; Munster and Leinster Bank, Ltd, Cork 178; National Gallery of Ireland, Dublin 1, 45, 47–50, 56, 57, 60, 61, 63, 64, 66–70, 72, 82, 90, 92, 98, 100, 101, 106, 107, 110, 112–15, 120, 122, 126–30, 133, 140; National Museum of Ireland, Dublin 3–6, 8, 12–14, 29–31, 37–9, 80, 81; National Museum of Wales 117; National Portrait Gallery, London 43, 65, 97, 102, 105, 119; Gordon Nettleton Esq. 148; Ritchie Henriks Gallery, Dublin 155, 162; Royal Dublin Society 74, 75; Royal Hibernian Society 54; Scottish National Gallery of Modern Art 124; Sligo County Library and Museum Art Collection 151; Edwin Smith Esq. 77–9; Trustees of the British Museum, London 16, 17, 40; Trustees of the Tate Gallery, London 58, 103, 121, 123, 136; Ulster Museum, Belfast 42, 51, 52, 89, 93, 95, 111, 135, 137, 144, 150, 156, 158, 161, 164–6, 172, 176; Victoria and Albert Museum, London 84, 91, 96, 99; Victor Waddington Esq. 131, 134; Walker Art Gallery, Liverpool 118; Whitworth Art Gallery, Manchester 62; Mrs H.L.S. Young 51

Index Page numbers in *italic* refer to illustrations